SOMETHING SWEET

CONTENTS

This monograph is published on the occasion of the first major one-person exhibition, *IT IS YOU,* by British artist, Mark Titchner. Working across a number of media including print, wall drawing, video, sculpture and installation, Titchner's practice explores systems of belief, both secular and spiritual, often focusing on the marginalised, discredited or forgotten ideologies and objects we place our faith in. Using the impersonal language of the public realm, ranging from the quasi-mysticism of corporate mission statements to the maxims of revolutionary socialism, his work exhorts us to believe in it. Motifs taken from advertising, religious iconography, club flyers, trade union banners, rock music, political propaganda, and even occultism, all vie for our attention. The common denominator of this vocabulary of idealism is a quest for enlightenment; a desire for some form of trans-cendence; and yet, abstracted from its original context, the message appears drained of meaning. The vision of a brave new dawn has become clouded. We know that we are being asked to respond, just as Pavlov's dogs responded to the tinkling of a bell, but the purpose is unclear. All we are left with is the formal means of exhortation, and our own unrelenting desire for meaning. It is this fundamental human need that Titchner's work exposes so succinctly.

IT IS YOU is curated by Martin Clark, Arnolfini's Curator of Exhibitions. The exhibition has been realized with generous support from Arts Council England, as part of Arnolfini's re-opening programme following a two-year closure for the re-development of its premises. Two new commissions in the exhibition have been made possible by a grant from the Elephant Trust out of the George Melhuish Bequest, for which we are very grateful.

We would like to thank Rachel Williams and Mark Dickenson at Vilma Gold for all their help and support, in particular with the production of this catalogue. Above all, we would like to thank Mark Titchner for his whole-hearted commitment and enthusiasm for the project.

Tom Trevor
Director

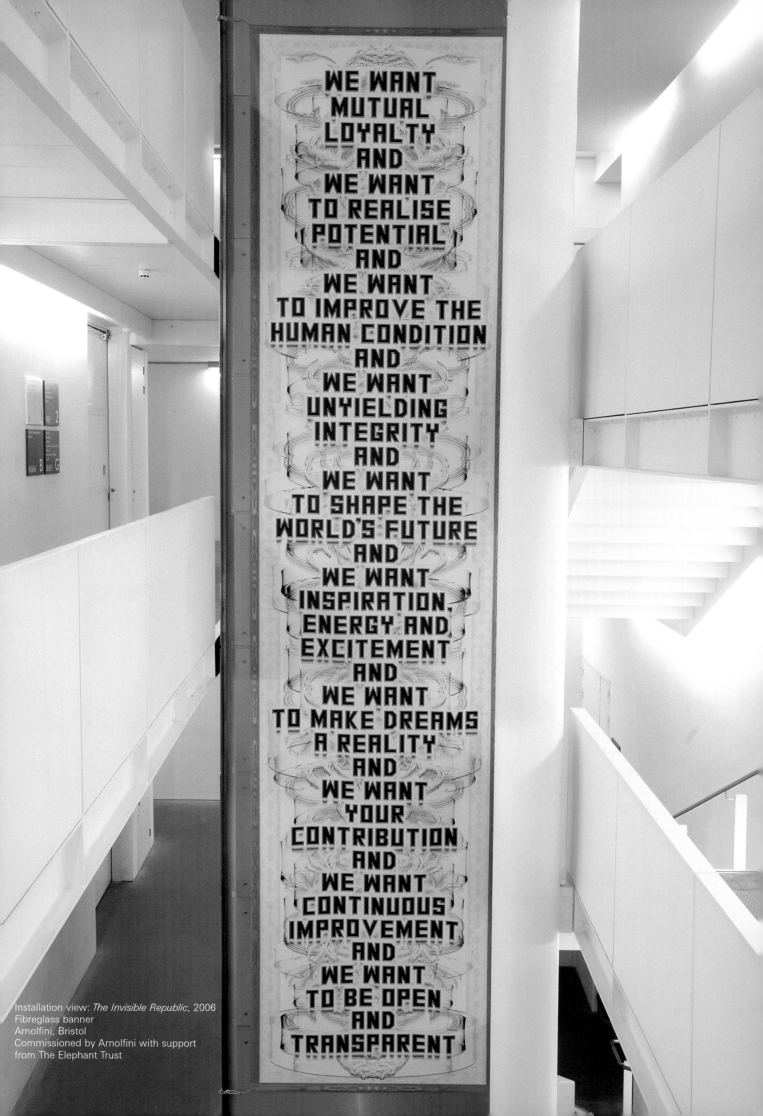

WE WANT
MUTUAL
LOYALTY
AND
WE WANT
TO REALISE
POTENTIAL
AND
WE WANT
TO IMPROVE THE
HUMAN CONDITION
AND
WE WANT
UNYIELDING
INTEGRITY
AND
WE WANT
TO SHAPE THE
WORLD'S FUTURE
AND
WE WANT
INSPIRATION,
ENERGY AND
EXCITEMENT
AND
WE WANT
TO MAKE DREAMS
A REALITY
AND
WE WANT
YOUR
CONTRIBUTION
AND
WE WANT
CONTINUOUS
IMPROVEMENT
AND
WE WANT
TO BE OPEN
AND
TRANSPARENT

Installation view: *The Invisible Republic*, 2006
Fibreglass banner
Arnolfini, Bristol
Commissioned by Arnolfini with support
from The Elephant Trust

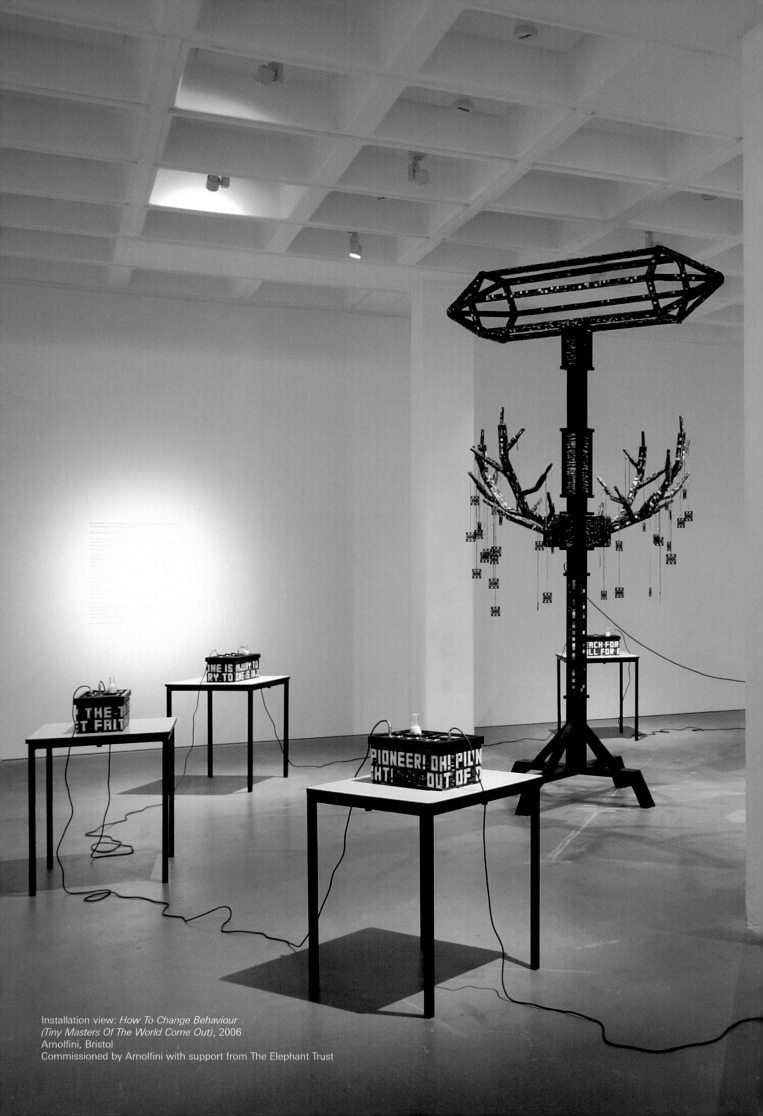

Installation view: *How To Change Behaviour*
(Tiny Masters Of The World Come Out), 2006
Arnolfini, Bristol
Commissioned by Arnolfini with support from The Elephant Trust

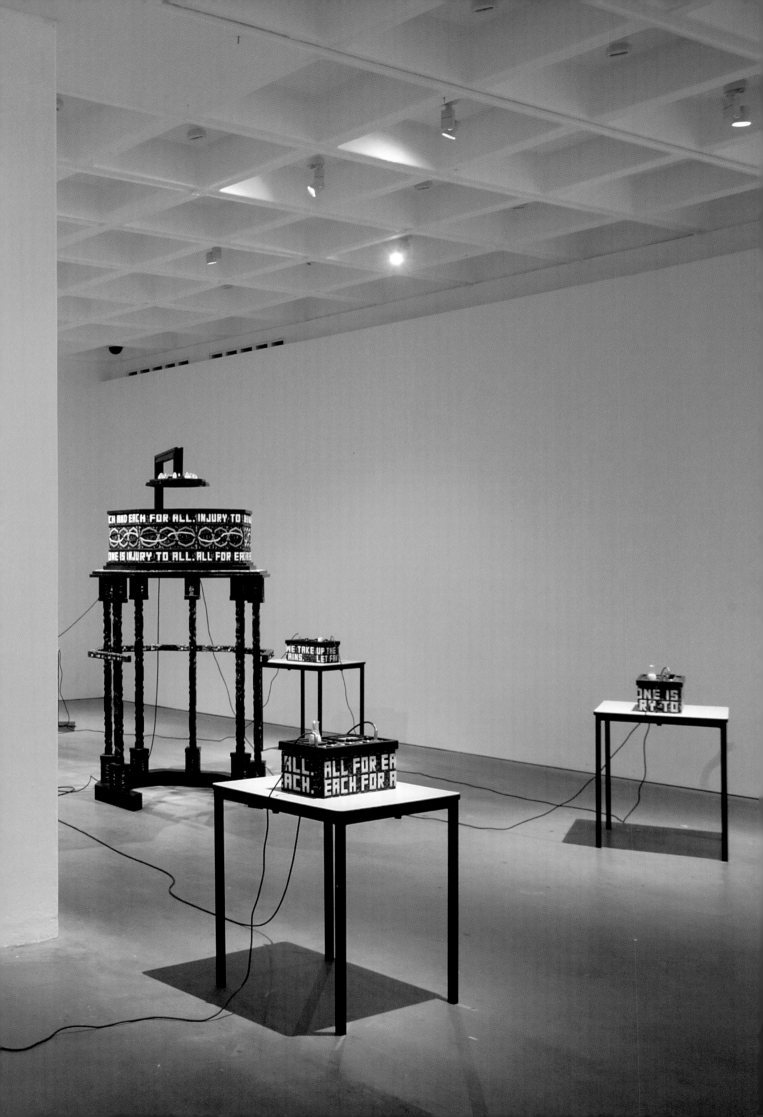

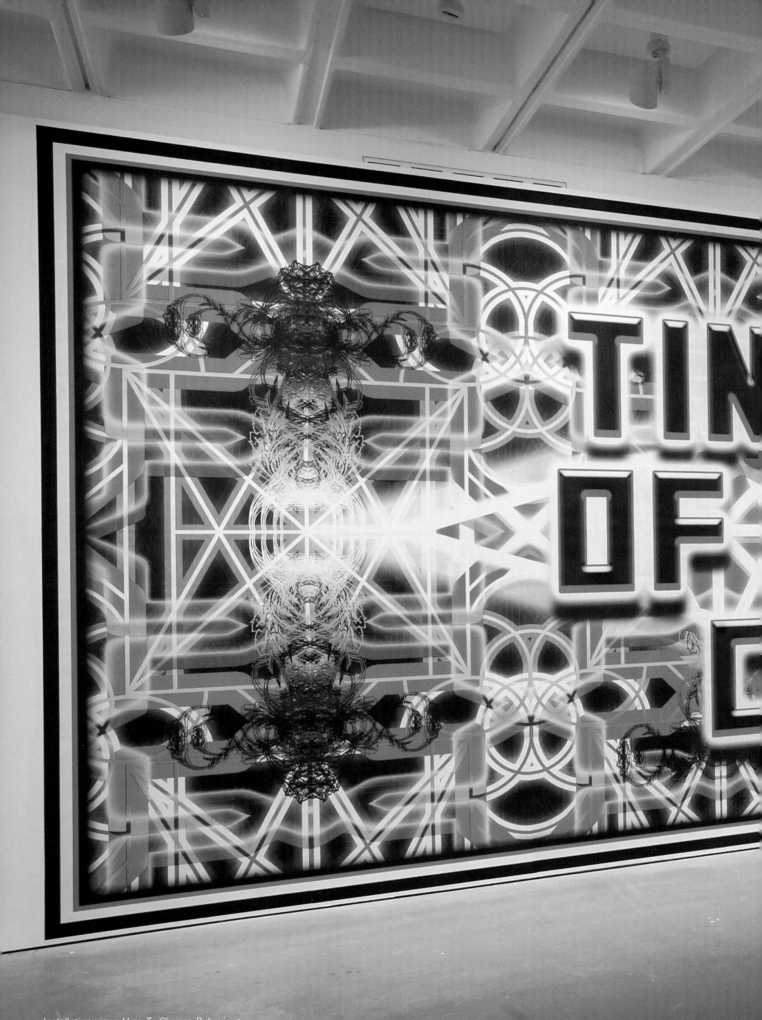

Installation view: *How To Change Behaviour*
(Tiny Masters Of The World Come Out), 2006
Arnolfini, Bristol
Commissioned by Arnolfini with support from The Elephant Trust

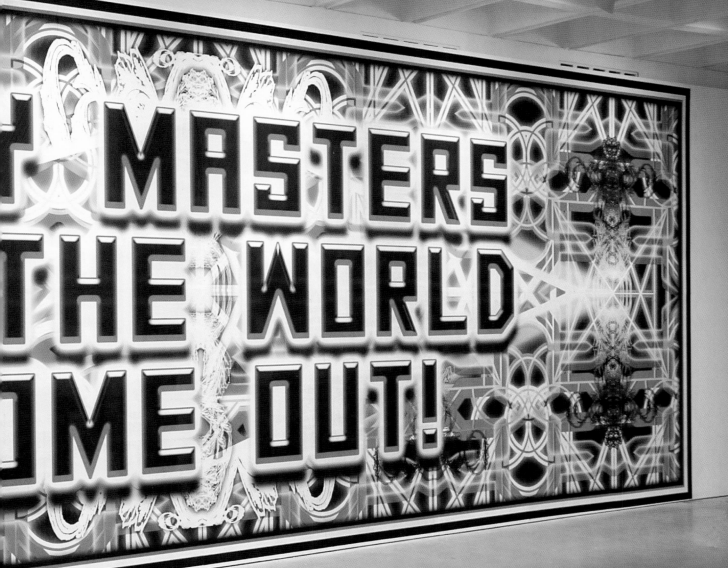

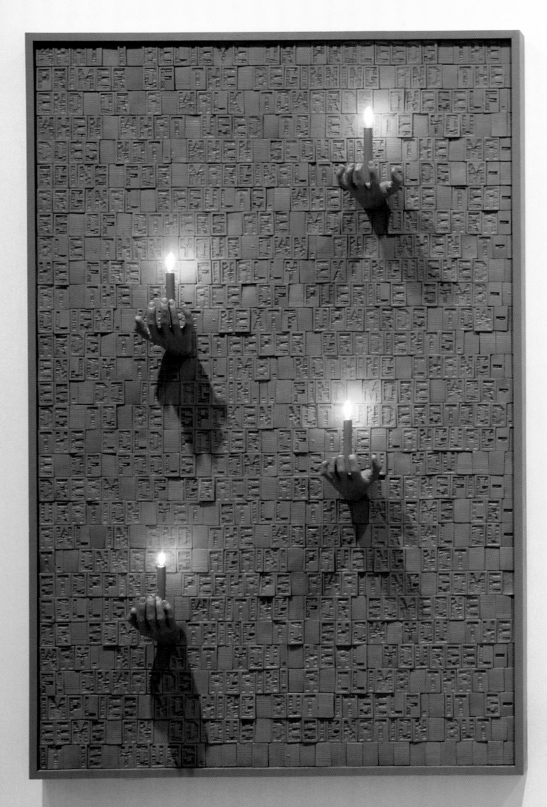

Proceeds The Primer, 2006
Jesmonite, paint, plaster, candles
Courtesy the artist and Vilma Gold, London

Dark Implications, 2005
Jesmonite, paint, plaster, candles
Courtesy the artist and Vilma Gold, London

Installation view: Arnolfini, Bristol

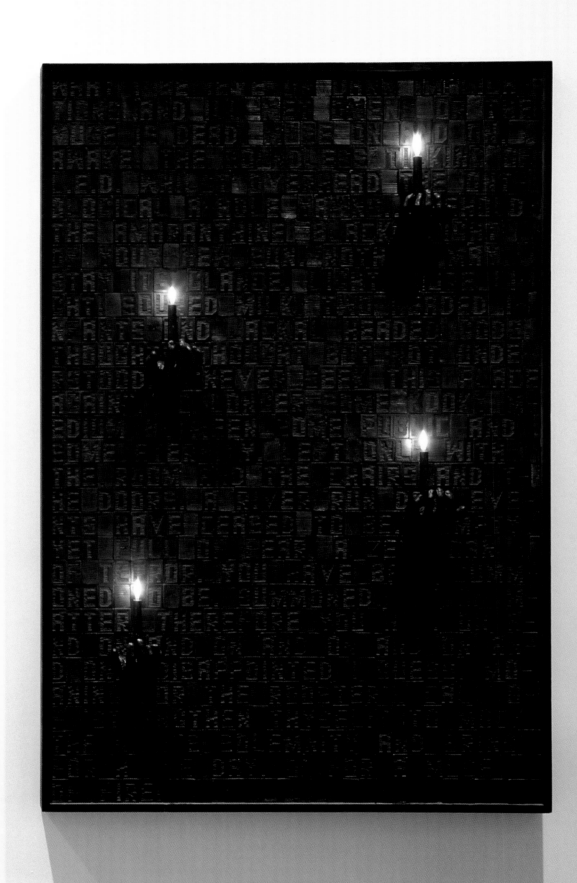

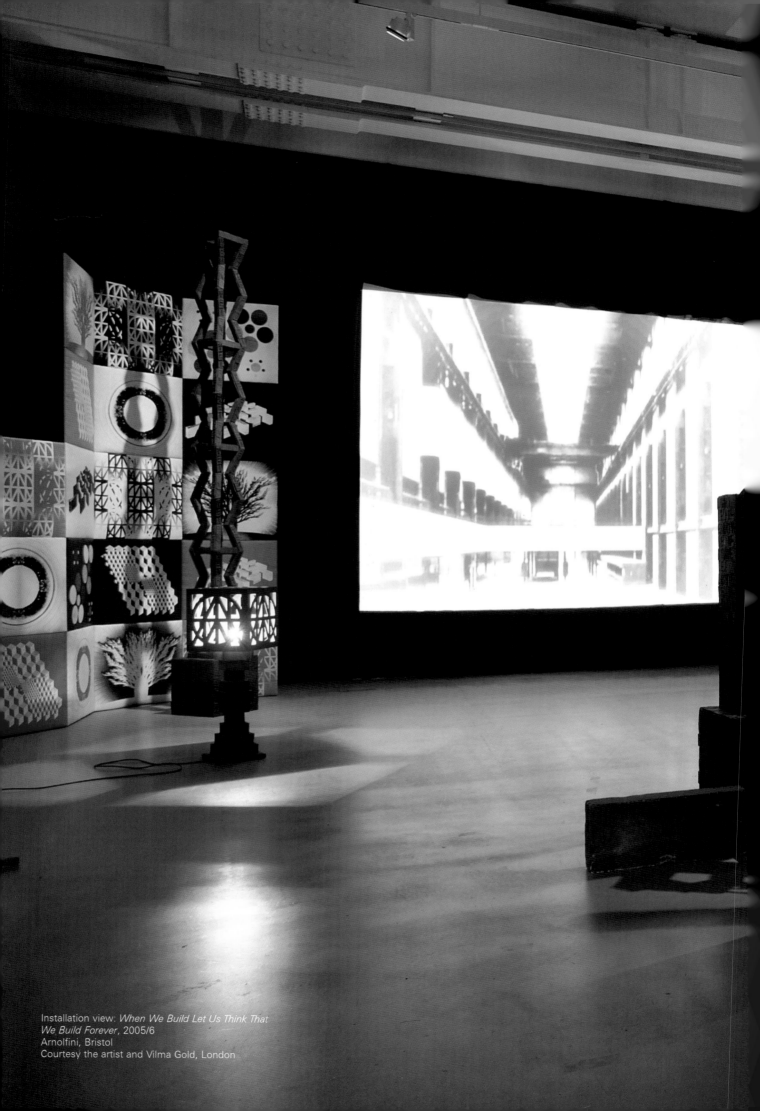

Installation view: *When We Build Let Us Think That We Build Forever*, 2005/6
Arnolfini, Bristol
Courtesy the artist and Vilma Gold, London

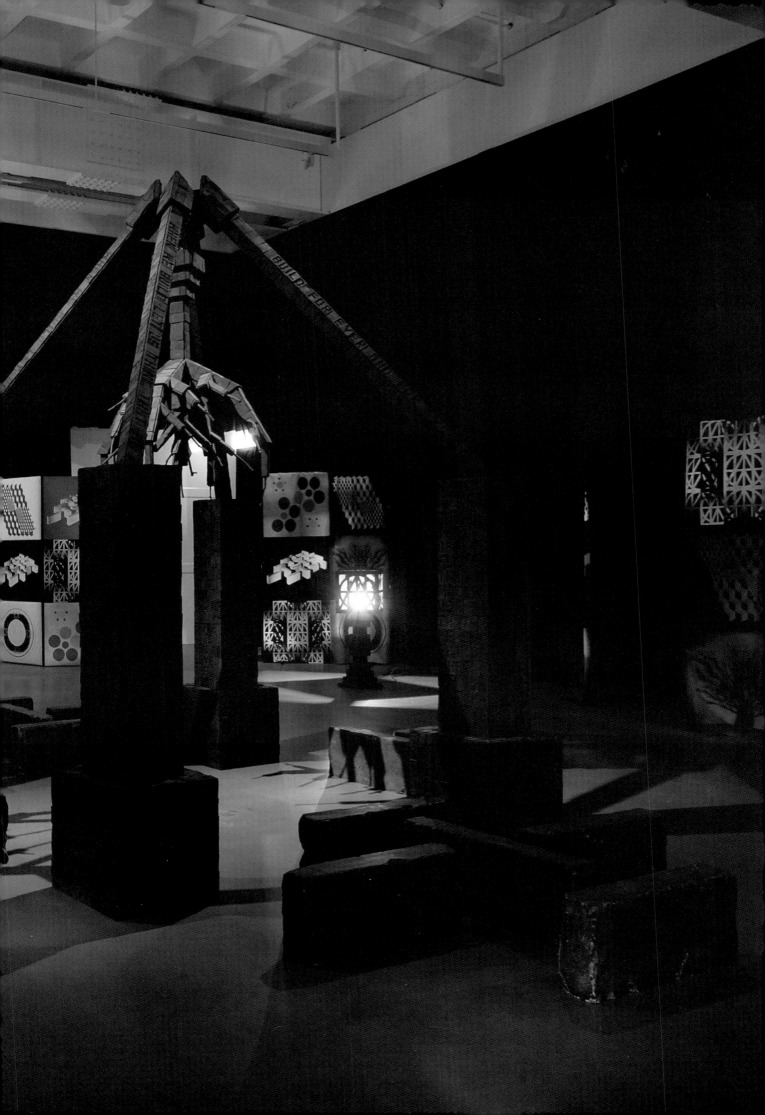

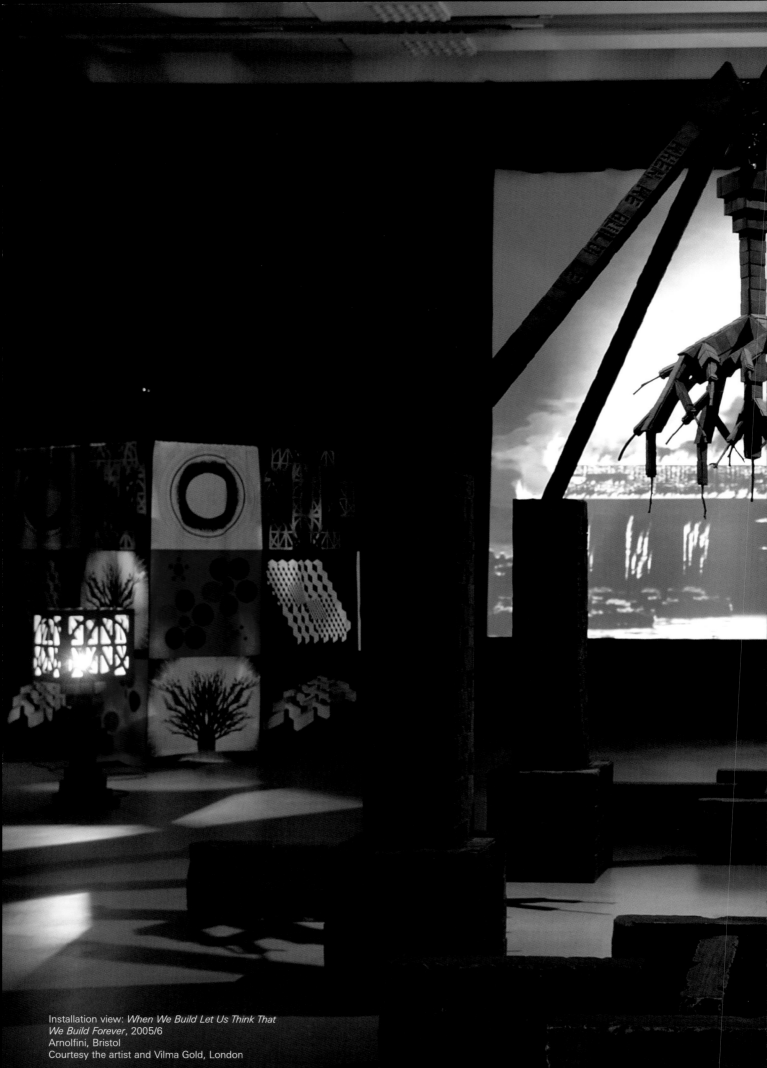

Installation view: *When We Build Let Us Think That
We Build Forever*, 2005/6
Arnolfini, Bristol
Courtesy the artist and Vilma Gold, London

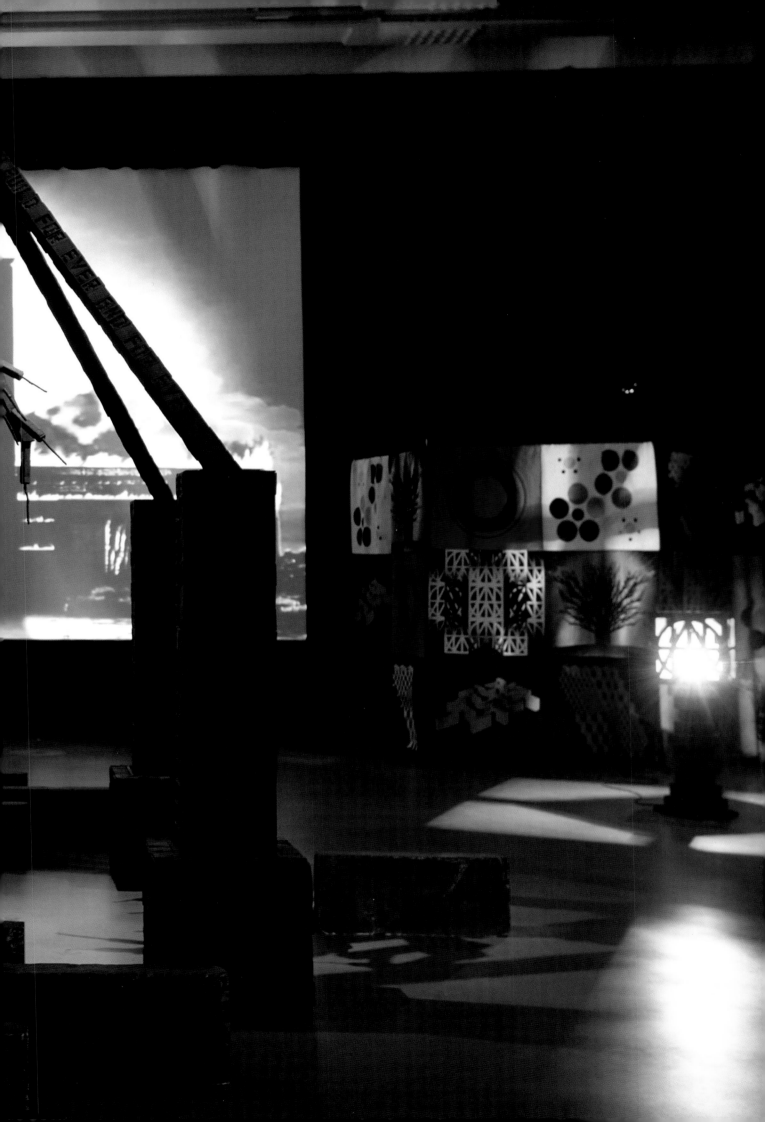

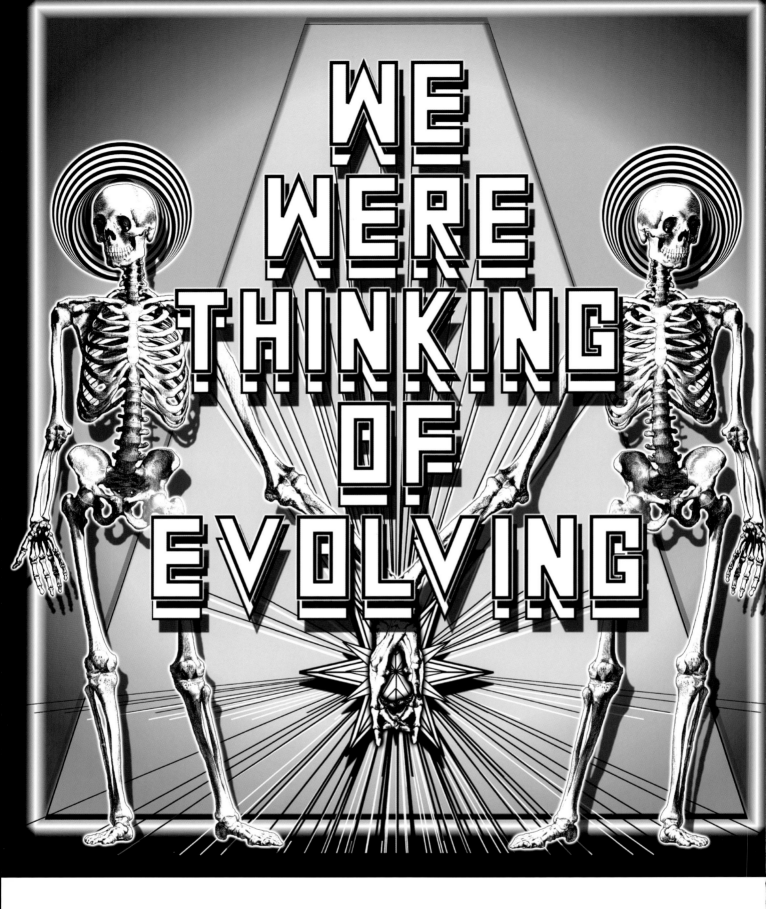

We Were Thinking Of Evolving, 2003
transparency in lightbox in carved frame
120 x 120 x 15 cm
Collection Archibald Williams, London

STRIPTEASE OF THE LITERARY EXECUTOR

My basic theory is that the written word was actually a virus that made the spoken word possible. The word has not been recognized as a virus because it has achieved a state of stable symbiosis with the host, though this symbiotic relationship is breaking down, for reasons I will suggest later. [i]

In Daniel Odier's *The Job* we are introduced to the myriad influences, methodologies and nagging preoccupations of the writer William S. Burroughs. Sifting through the ideological baggage of the twentieth century, Burroughs considers the means by which information is transmitted and received: he is a 'literary scientist' to whom no aspect of the human condition is less than fascinating. Discussion trails from the fringe science of Wilhelm Reich and L. Ron Hubbard, continuing over the barricades to the use of sound as a military weapon, and skywards to the dissolution of nationhood. Referring to the work of scientists Wilson Smith, Dr Christopher G. Belyavin and the mysterious Dr Kurt Unruh von Steinplatz (we are never sure as to the legitimacy of the latter) Burroughs suggests that 'alterations in the primal ape's inner throat structure occasioned by a virus illness' allowed for the evolution of the spoken word. He advances the theory: 'So now with the tape recorders of Watergate and the fallout from atomic testing, the virus stirs uneasily in all throats,' continuing that, with the advent of the 'electronic revolution, a virus is a very small unit of word and image.' The word has come of age, biologically activated as a communicable strain.

All hate, all pain, all fear, all lust is contained in the word.[ii]
A poster in an advertising lightbox depicts two skeletal figures, bony hands clasped as their empty sockets stare out into the street. The text reads: 'We Were Thinking Of Evolving', also the title of the work. It's a casual-sounding proposition, yet at its bleakest it recognises a possible evolutionary phase entirely dependent on humanity's demise. Simply put, Mark Titchner's work is about belief, a recognition perhaps that the human spirit has infinite potential but is for the most part making do in a crappy world.

As Burroughs explored the possibility of alternative time-lines and fringe science theory, so too does Titchner. The chosen forms of such exploration are many and varied. A preliminary list of the 'tools of his trade' might read: hand-printed poster, digital poster, printed t-shirt, hand-crafted wooden sculpture, digital animation, vinyl record, billboard, aural sculpture, placard, light-box, banner, wall mural, print publication – yet the impetus, the content, remains the same. If the word is a 'communicable virus', how are our actions manipulated by it? What are the consequences of a world swamped in text? What is discarded and what is acted upon?

[i] William S. Burroughs with Daniel Odier, *The Job: Topical Writings and Interviews*, John Calder Publishers, 1969

[ii] William S. Burroughs with Daniel Odier, *The Job: Topical Writings and Interviews*, John Calder Publishers, 1969

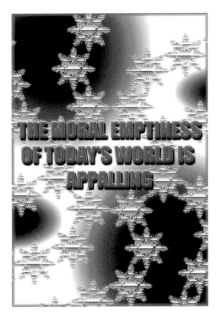

The Moral Emptiness Of Today's World Is Appalling, 2002, transparency in light-box, 185 x 125 x 15 cm
Private Collection, The Netherlands

Titchner is the epistemological journeyman, re-hydrating the freeze-dried ideologies of history. Committed to the proverbial blender, we are left with the pithy seeds of former texts. 'In our infinite ignorance we are all equal'; 'The moral emptiness of today's world is appalling'; 'Give me the shot, give me the pill, give me the cure'; 'Begin Now'. Chosen texts plucked from evangelical literature, pop lyrics, political and philosophic tracts, presented via the stunted aphorism, that bastard, yet hopeful child of literature. It is a manicured, highly managed and overtly mannered form of expression. Mounted upon dense, multi-layered backgrounds that fall somewhere between the psychedelically inspired posters of Haight-Ashbury, the blunt graphic approach of suburban Heavy Metal and the nervous tics of modernity, Titchner's phrases propose a form of statelessness; the individual constructed from the navigation of multiple textual beginnings. From what you have already experienced in this publication – if you're anything like me a cursory glance at the images helps to inform the purchase – it is probably clear that what we are dealing with here is an advanced strain of the 'word and image' virus. Desire lines that suggest alternative paths through the liberating imagination of independence from fixed ideologies.

To what extent do we have a responsibility to the past? Is it any more than a reflection, a gnarled literary face momentarily glimpsed in passing? What is the intended force behind the re-examination of existing texts? Perhaps it has its basis in an earlier age; those formative years that range from late teens to early adulthood. For most developing readers there are touchstones that ease such a passage, the words of a favoured musician or author, a specific passage from a song or piece of writing. It is an adopted identity that is on occasion presented to the world through the addition of a lyric or political slogan inscribed upon a preferred item of clothing or furtively scribbled in the margins of a textbook. What Titchner proposes is that these minor or major truths, received and held close in the literary 'cult classics' period of development, are key to our organised sense of self. A brief checklist of such a literary pro-genesis might include: H. P. Lovecraft, Richard Brautigan, J.D. Salinger, Michael Moorcock, Ursula K. Le Guin, Charles Bukowski, Philip K. Dick, Thomas Pynchon, Bob Dylan, Joan Didion, Oscar Wilde and William S. Burroughs. Needless to say, many continue with us: those texts that possess the power to enchant and inform long past the naiveté of youth.

All literature, but especially literature of the weird and the fantastic, is a cave where both readers and writers hide from life. It is in just such caves – such places of refuge – that we lick our wounds and prepare for the next battle out in the real world. When in short the imagination is moulting.[III]

Why and Why Not?
Within Titchner's self-penned publication *Why and Why Not?* (2004),[iv] ten chapters progress with the speed of gnashing teeth and the evangelical zeal of the street-corner prophet. The whole has something of the urgency of formative writing, some vestige of the weird and fantastic. It is reminiscent of an early publication by Crass front-man Penny Rimbaud, *A Series of Shock Slogans and Mindless Token Tantrums* (1982),

iii Stephen King, Michel Houellebecq, *H.P. Lovecraft; Against the World, Against Life,* Believer Books, SF, CA, 2005
iv Mark Titchner, *Why and Why Not?,* Book Works, London, (ed. Mark Beasley), 2004

titled after an article about the band in the mainstream tabloid press.[v] In the book, Rimbaud decries the erstwhile punk of leading protagonists the Sex Pistols and The Clash as marketing 'soft revolution' and re-examines the thoughts and deeds of Charles Manson, Timothy Leary and Errico Malatesta. Combining hard facts, bitter humour and a distinctive graphic style, the pocket-sized black and white tract-cum-rant was the must have for a generation of eighties post-punks.

The opening chapter of *Why and Why Not?* takes its title, *I Against I*, from a track by the hardcore punk band Bad Brains in which youth ponders the perceived mistruths of the parent culture. Punctuated by Titchner's signature graphics and text – 'A corpse in your mouth.', 'Rub out the word.', 'Who speaks for you.' – the internalised discussion has one recurrent theme: that of 'doubt'. It is a conflicting voice that is essentially the artist's own, a philosophical and Socratic attempt to reveal truth through disputation. A nod to the recurring Nietzschean refrain: What if the opposite is true? What if? What if?

The Delivery Mechanisms of the Subliminal Present

Moving from the printed page to digital video, *Artists are Cowards* (2002) presents a series of images and half-registered texts revolving and strobing on screen. A goldfish circles endlessly – a lesser know Duchamp rotorelief – overlaid with Beckett's text 'Fail Again, Fail Better'. The logo of Vertigo Records – home of Black Sabbath – spins anticlockwise, an unlikely backdrop for Hegel's tautology 'The Rational Is Real. The Real Is Rational.' It is a conflict of ideologies that conflates the urban myth of Vertigo discs played backwards summoning the devil, with the aphoristic certainty of philosophic thought. Squatting the collapsed space between philosophy and pop culture, Titchner again attempts to rewire seemingly irreconcilable texts. It is perhaps intended as a bizarre training video for the radical recoding and activation of the individual; the schizophrenic hearing voices pre-action.

Relatively Speaking

Numbered as one of the Sophists by Plato, the Greek philosopher Protagoras (481 BC) is regarded as the father of Relativism. Simply put, this school of thought asserts that all perceived relations are relative and contingent. A famous teacher of rhetoric and debate, his lasting maxim holds true for the work under discussion, 'man is the measure of all things.' More pertinent perhaps are the thoughts of German philosopher Hans-Georg Gadamer. A contemporary of Heidigger, Gadamer argued that people have a 'historically effected consciousness'. That is to say that over time we gather concepts and frameworks of understanding. Thus, interpreting a text involves a 'fusion of horizons' wherein the reader explores the ways in which a text's history communicates and intertwines with their own background. In extrapolating and combining texts, Titchner presents a DIY epistemology drawn from the far-flung corners of literature: a peculiar act of literary recall in the margins of history. Let's call them Post-it notes from the past, the stubborn and less palatable thoughts that gnaw at the mind in the dead of night. Is it a search for some kind of truth? Does it bring new agency or by way of

Video stills: *Artists Are Cowards*, 2002
DVD loop, duration 10 mins
Tate, London, 2006

[v] Penny Rimbaud, *A Series of Shock Slogans and Mindless Token Tantrums*, Exitstencil Press, 1982 (Originally issued as a pamphlet with the LP *Christ the Album*.)

remembrance placate history's marginal figures? Giving voice to one's fears and anxiety is perhaps what Plato may have described as loosing the reflective mirror upon the monster.

You Hear A Joke About Yourself And You Join In The Laughter: an aside from Woody Allen's 1972 film Play It Again Sam, in case (relatively speaking), I missed the joke.

Allan (Woody Allen): That's quite a lovely Jackson Pollock, isn't it?
Museum Girl (Diana Davila): Yes, it is.
Allan: What does it say to you?
Museum Girl: It restates the negativity of the universe, the hideous, lonely, emptiness of existence. Nothingness. The predicament of Man forced to live in a barren, Godless eternity like a tiny flame flickering in an immense void with nothing but waste, horror and degradation, forming a useless bleak straitjacket in a black absurd cosmos.
Allan: What are you doing Saturday night?
Museum Girl: Committing suicide.
Allan: What about Friday night? [vi]

Watch Out the World's Beside You

Along a stretch of Midlands railway banking a multitude of placards, *Everyone Responsible for Everything They Do. Why Not?* (2002), are fleetingly visible from the carriage. Each displays a text or statement borrowed from the worlds of pop music, philosophy and theology. A high-speed version of William Burroughs's cut-up text, there are no correct readings, no idealised positions or absolutes, no single work to be viewed. Perversely, given the work's placement 'out there' in the world, it relies upon a form of internalisation, a willingness to consider the information provided. It is the choice of the individual to accept the conditions of exchange, to plot their own readings and interpretations. Each subsequent journey and differing position provides new content and layering of information.

Maybe Titchner's approach has something to do with the Copernican principle, that moment in history when the Polish astrologer Nicolaus Copernicus looked to the skies and demonstrated that the motions of the heavens could be explained without the Earth being at its core, thereby doing away with the assumption that we as a species are observing from a 'special' position. His primary maxim being 'there is no one centre in the universe.' [vii] It is a philosophy continued by Kant through his theory of the 'autonomy of reason'; the suggestion that morality is a question of individual choice, not something to be mediated by others. As Titchner proposes, we are all responsible for making choices and defining the greater goals of our individual existence.

In fact history does not belong to us; but we belong to it. The self-awareness of the individual is only a flickering in the closed circuits of historical life. That is why the prejudices of the individual, far more than his judgments, constitute the historical reality of his being.[viii]

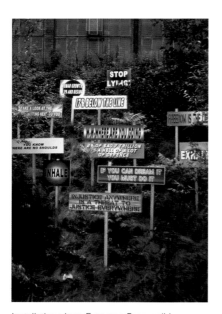

Installation view: *Everyone Responsible For Everything They Do. Why Not?*, 2002
West Bromwich
Courtesy the artist and Vilma Gold, London
Commissioned by The Public, West Bromwich

[vi] *Play It Again Sam*, Directed by Herbert Ross from a screenplay by Woody Allen, A Paramount Picture, 1972
[vii] Nicolaus Copernicus, *On the Revolutions of the Heavenly Spheres*, 1543

Extracted from the corporate manifestos of ten leading consumer brands – 'We want strong leadership.'; 'We want to make dreams a reality.'; 'We want answers to the questions of tomorrow.'; 'We want your contribution.' – *I WE IT* (2004), a series of billboards sited at Gloucester Road Underground station, conflates the manifestos of late capitalism with the Black Panther Party's *Ten Point Program* of 1969. In terms of graphic presentation the billboards are reminiscent of British trade union banners, strong declarative statements set against emblematic imagery. Prefixed with the Panthers' declarative 'We want', the mission statements assert a desire for liberated self-control, only this time presented as a group request. It is an ideological stalemate that reflects the universal desire for control, either wrested from the hands of oppressive forms of governance or co-opted in the market place. It is the point at which 'I' becomes 'We', the understanding of self, filtered through the thoughts and collective aspirations of others, either freely given or taken without warning.

Banner Bright

Let the winds lift your banners from far lands, with messages of strife and hope. Your cause is the hope of the world.[ix]

A means of expression and unity, British trade union banners displayed the tools and processes of the trade. Their earliest recorded use dates back to the reform protests and the trade societies of the early 1830s. The banners would typically depict the benefits that could accrue from union membership: the dignity of the trade, brotherhood, unity and justice. A banner, after all, is a symbol of unity, of all that is most active and positive within union culture. The banner both reflects a union's role and concerns and acts as a tangible symbol of idealism. There should be no ambiguity in its meaning – after all, these are banners one holds aloft. In conflating the imagery of the progressive left (trade union culture and the Black Panthers) with those of late capitalism, what appears to be a reasoned request – albeit in bombastic graphic terms – takes a more sinister twist. On whose behalf are these requests made? What cause are we presented with?

Many Weak Fingers Form A Fist

In *Do What You Must Take What You Can* (2004), a lotus flower erupts with clenched fists. The clenched fist, a symbol associated with the defiance of authority and personal empowerment, appears often within Titchner's adopted ideography. Thought to have originated during the Spanish Civil War (1936-1939) and used by the communists as a symbol of unity, it has been described as the anti-fascist salute; many weak fingers coming together to represent a unified strength. The poster work *Love Life Through Labour* (2003) employs honeycomb fractals suggestive of the hive mind and infinite expansion through cooperative action. The disparate elements of the installation *Be Angry But Don't Stop Breathing* (2003) are drawn together by the repeated use of the hexagon, the graphic symbol for benzene, a key solvent used in organic chemistry. For Titchner the employment of such imagery, from the banner to the raised fist, recalls a former time of collectivised activism

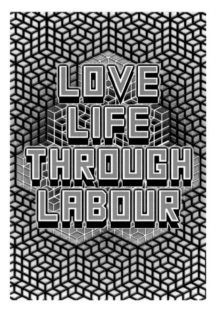

Love Life Through Labour, 2003
transparency in lightbox, 150 x 100 x 15 cm
Courtesy the artist and Vilma Gold, London

[viii] *Hans-Georg Gadamer, A Biography*, Jean Grondin, Yale University Press, US, 2004
[ix] Walter Crane, *Justice*, UK, 1894

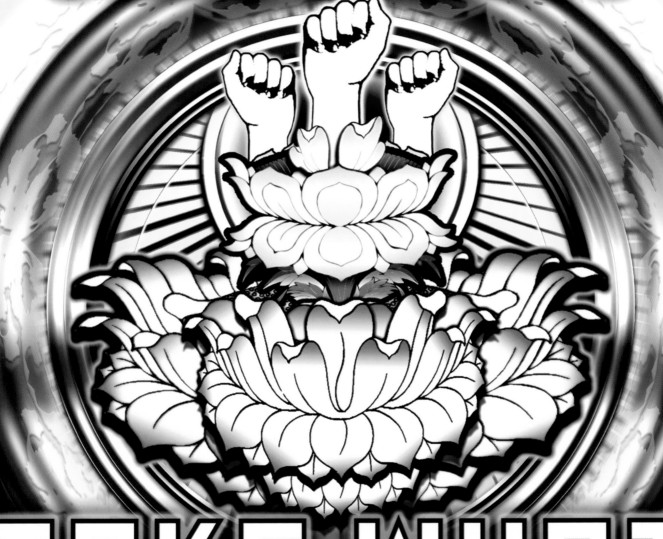

and solidarity; it is a call perhaps for the renewal of purpose for a largely apolitical and spiritually absent generation. A generation that experienced the dismantling of the Welfare state and trade unions throughout the Thatcher years and the implementation of The Criminal Justice and Public Order Act (1994).

Non-chemical Methods of Increasing Awareness

The sculpture *Resolving Conflict by Superficial Means* (2002) has at its heart a spinning Op art disc, providing a hypnotic backboard for an outstretched concrete hand which, in turn, is connected to a lump of rock. The viewer is invited to grasp the hand and release all inner angst into the stone. A kind of karmic sublimation, it is an open offer to complete the work that is generous and ridiculous in equal measure. For Titchner it seems that in order to effect change there has to be an action of sorts. To this end he culturally mines arcane and pseudo science for methods of increasing awareness; in *Orgone Accumulator* (1997) the artist pays homage to the work of Wilhelm Reich. Reich's orgone accumulator took the form of a six-sided box constructed from alternating layers of organic materials (to attract energy) and metallic materials (to radiate the energy toward the center of the box). Patients would sit inside the accumulator and absorb orgone energy through their skin and lungs. Reconstructed for the gallery, a machine that once offered escape and expansion is here presented as a handcrafted relic from a former, idealistic age. A reminder, perhaps, of what might have been, now couched metaphorically as a memento of discounted science.

The broad and open way is only one of many possible ways, but it has advantages. It enables us to see all sorts of artistic, intellectual, religious and political activities as part of one dialectical process, and to develop creative interplay among them. It creates conditions for dialogue among the past, the present and the future.[x]

Sprung from the congestion of usable images and codes, Titchner's world is one of ideas rather than the advocacy of any individual stance. In testing and picking apart the bones of once-virulent philosophies, he exerts what Antonio Gramsci describes as the 'pessimism of the intellect, optimism of the will.'[xi] His conditions for dialogue are expansive; it is an examination of the modern world and mindset in which we are both subject and object. In part he visualises the confused allegiances of the will, an ocular reflection of ideological and dialectic trauma: the belief that two contradictory positions could be said to be true. Yet, within such reflection, it could be said that there is a call for a renewal of purpose, that the playback and remixing of former texts could act as the agent for disruptive progressive change. It is a practice that asks questions of history placed at the feet of the present, recognising that we as individuals desire something to belong to, to believe in and to hold dear. For Titchner it appears that freedom of choice and response are the only authentic freedom. As we too sift our way through the baggage of the past it is only courteous to ask, whose banner are you waving? Is it a flag of convenience? Who speaks for you?

Mark Beasley

Installation view: *Show 47*, 1997
City Racing, London
Courtesy the artist and Vilma Gold, London

Opposite: *Do What You Must Take What You Can*, 2004, A2 poster
Courtesy the artist and Vilma Gold, London
Commissioned by VHDG, The Netherlands

[x] Marshall Berman, *All That Is Solid Melts Into Air: The Experience of Modernity*. Penguin Books, New York, US 1982

[xi] Showstack Sassoon, *Gramsci and Contemporary Politics*, Routledge, UK, 2000

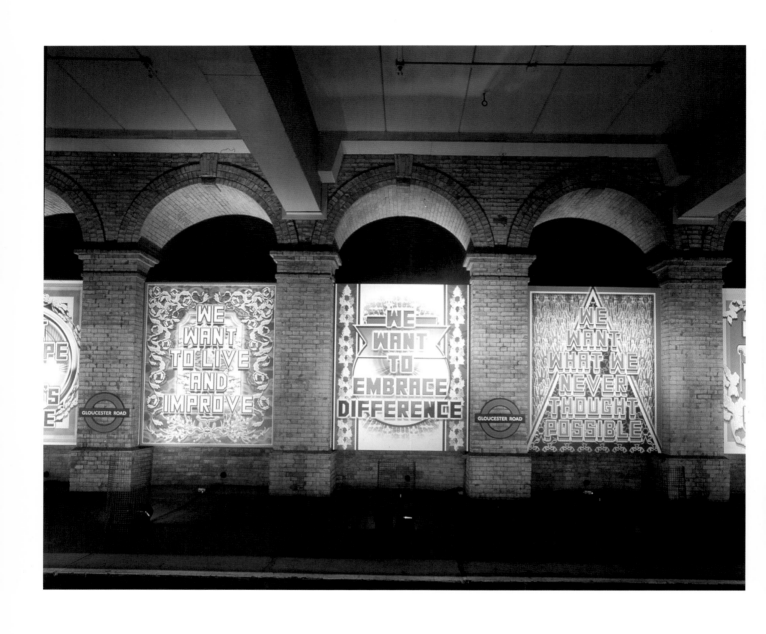

Installation view: *I WE IT*, 2004
Platform for Art, Gloucester Road Underground Station, London
Courtesy the artist and Vilma Gold, London
Commissioned by Platform for Art, London

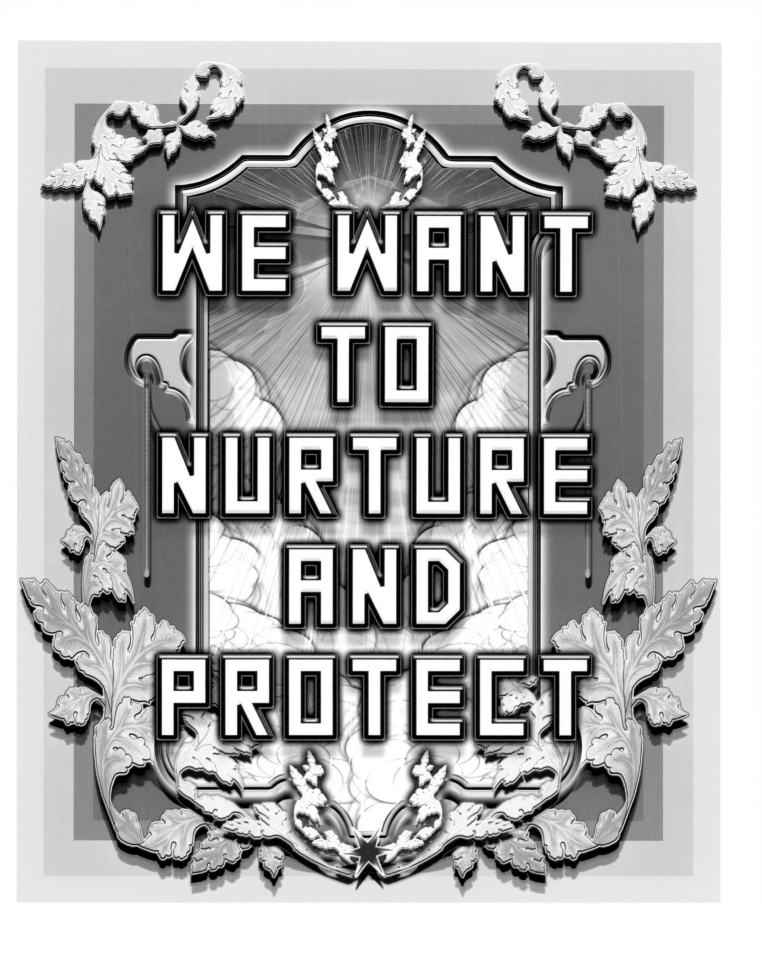

We Want To Nurture And Protect, 2004
print on aluminium, 293 x 239.5 cm
Copyright Tate, London 2006
Commissioned by Platform for Art, London

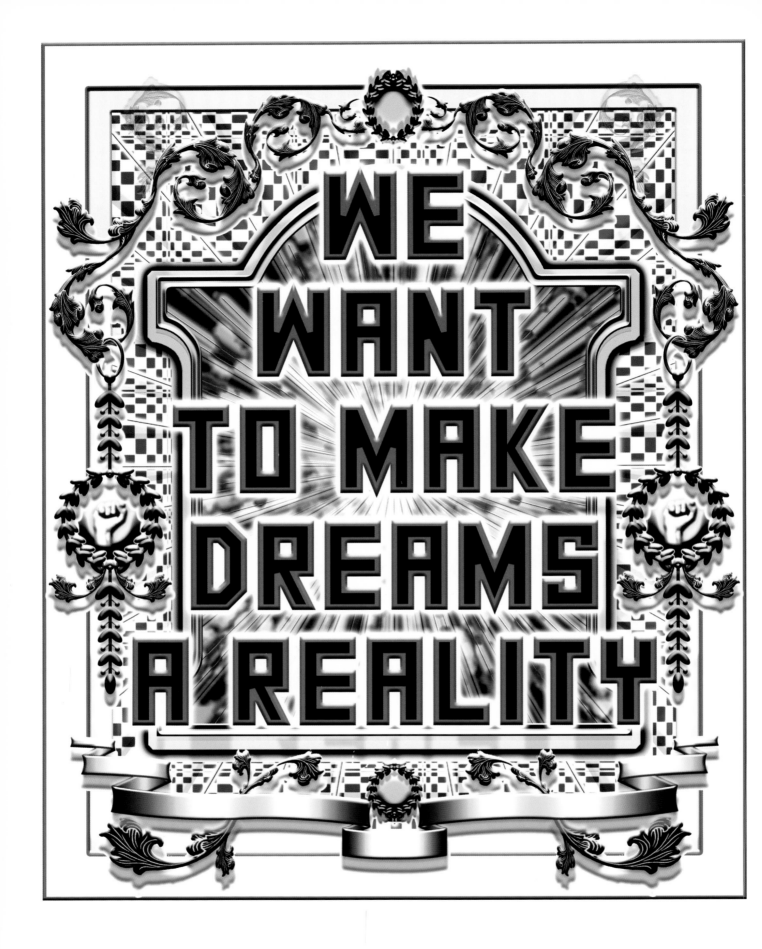

We Want To Make Dreams A Reality, 2004
print on aluminium, 293 x 239.5 cm
Vanmoerkerke Collection
Commissioned by Platform for Art, London

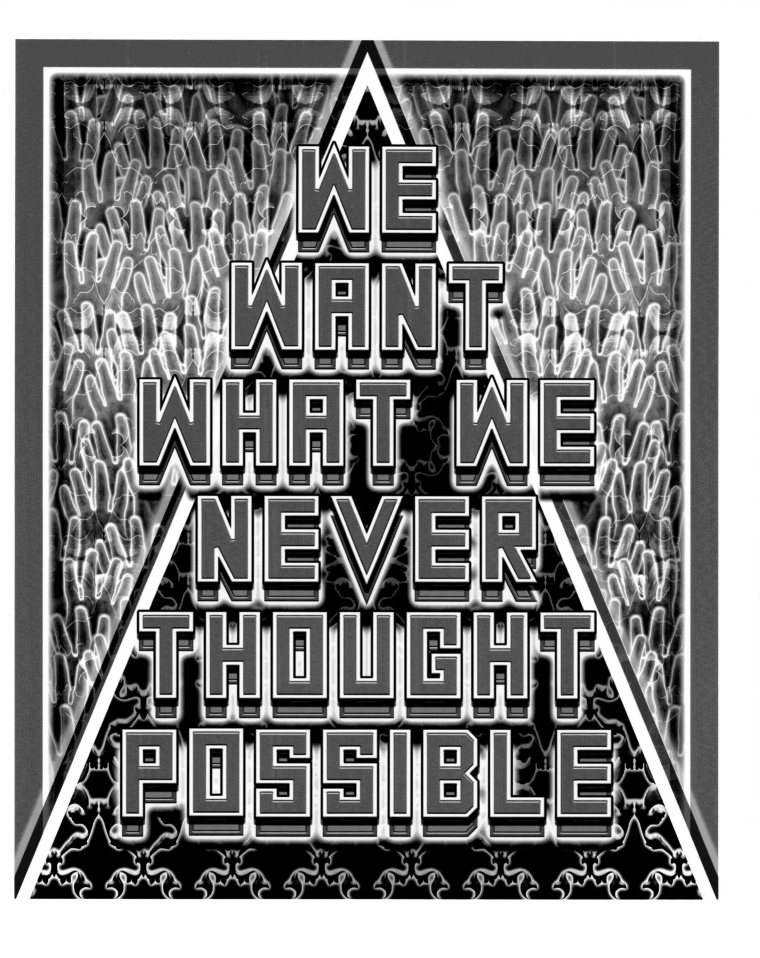

We Want What We Never Thought Possible, 2004
print on aluminium, 293 x 239.5 cm
The Speyer Family Collection, New York
Commissioned by Platform for Art, London

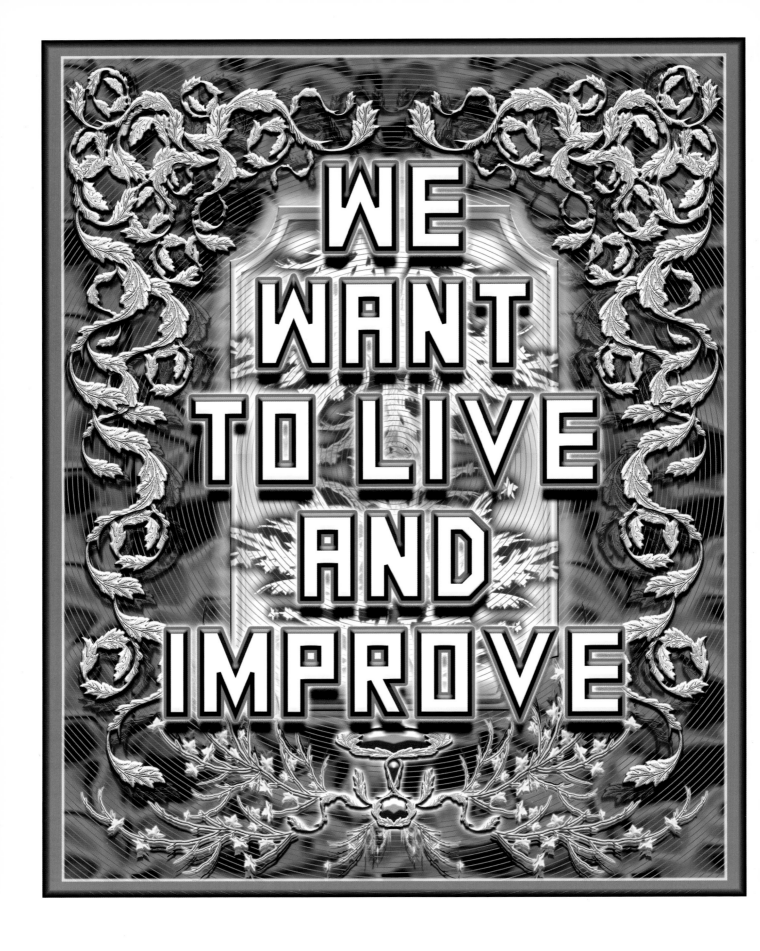

We Want To Live And Improve, 2004
print on aluminium, 293 x 239.5 cm
Private Collection, Japan
Commissioned by Platform for Art, London

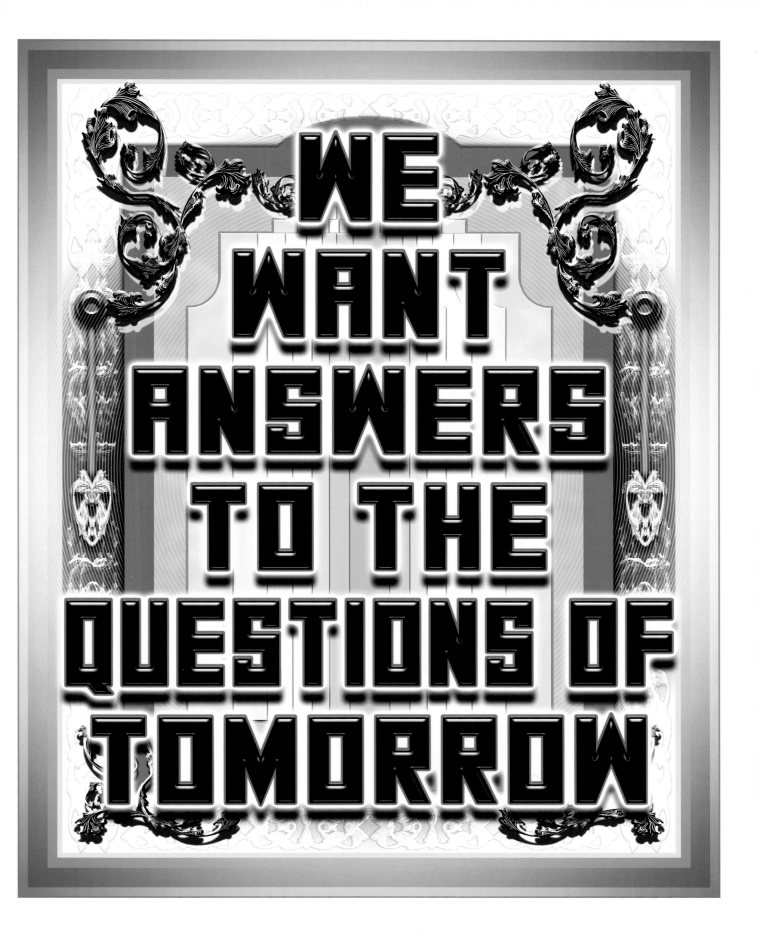

We Want Answers To The Questions Of Tomorrow, 2004
transparency in lightbox, 150 x 122 x 15 cm
Private Collection, London
Commissioned by Platform for Art, London

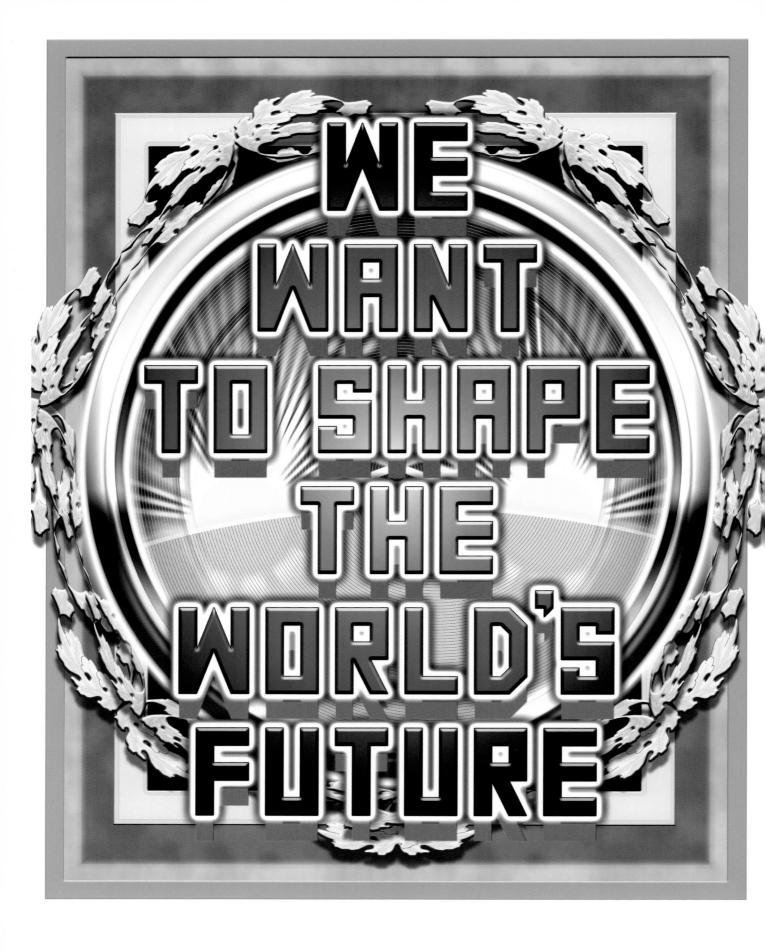

We Want To Shape The World's Future, 2004
print on aluminium, 293 x 239.5 cm
Collection Defares, Amsterdam
Commissioned by Platform for Art, London

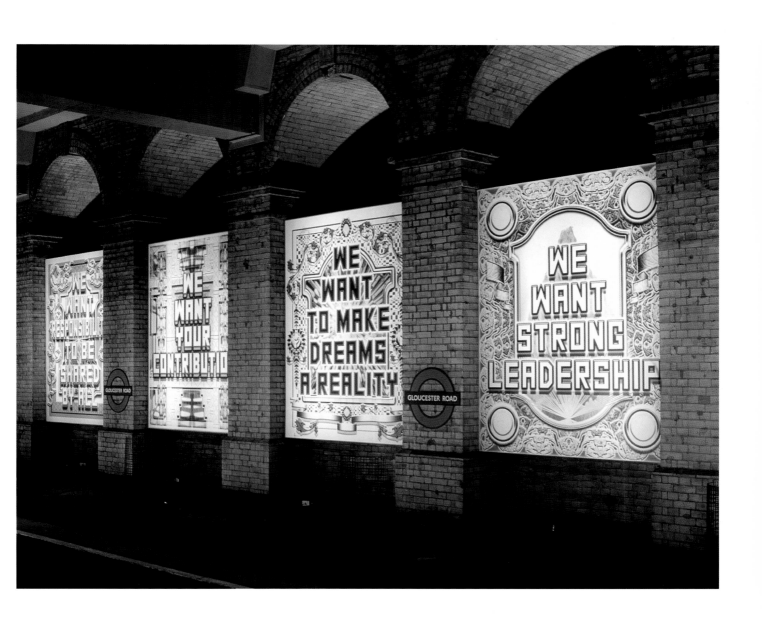

Installation view: *I WE IT*, 2004
Platform for Art, Gloucester Road Underground Station, London
Courtesy the artist and Vilma Gold, London
Commissioned by Platform for Art, London

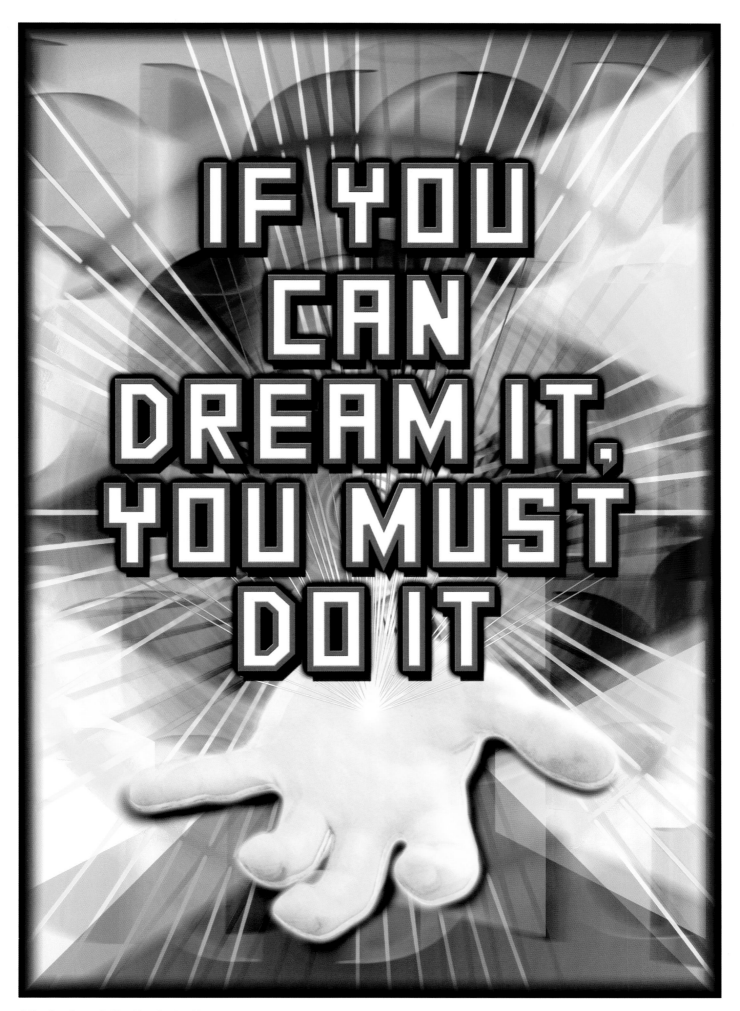

If You Can Dream It, You Must Do It, 2003
transparency in lightbox, 180 x 120 x 20 cm
Private Collection

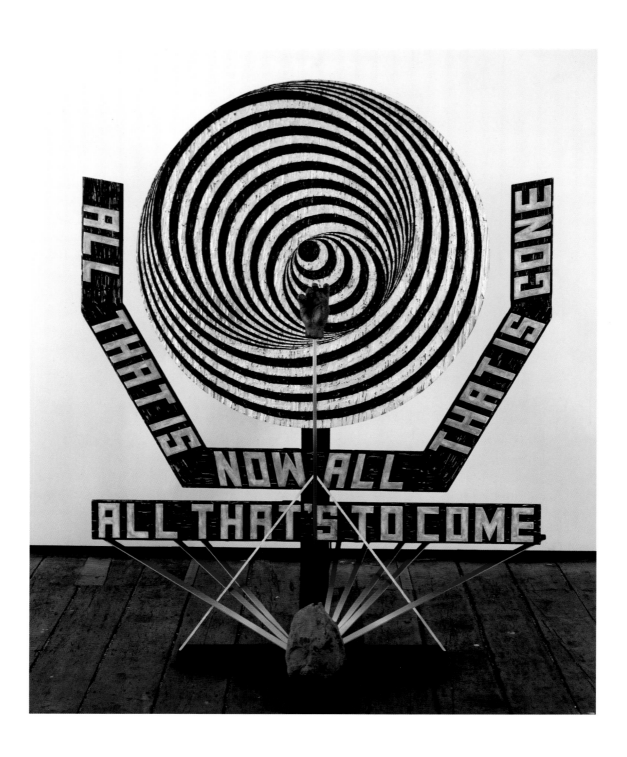

Resolving Conflict By Superficial Means, 2002
concrete, paint, carved wood, electric motor
200 x 160 x 80 cm
The Saatchi Gallery, London

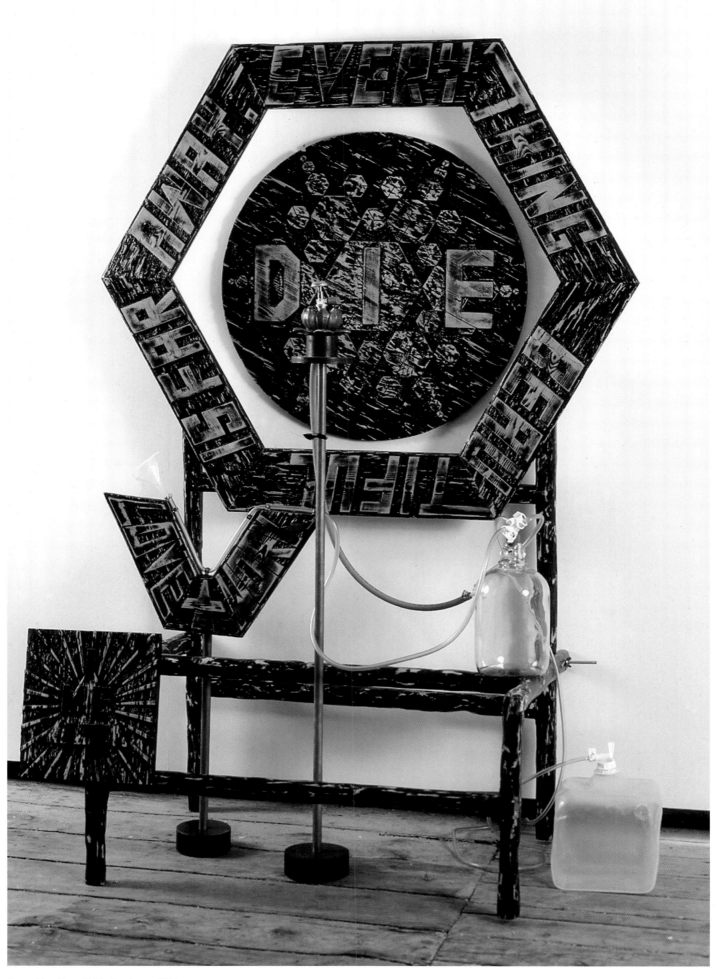

Everything Beautiful Is Far Away, 2003
carved wood, lead, gas burner, brewing equipment, paint
200 x 140 x 80 cm, courtesy the artist and Vilma Gold, London

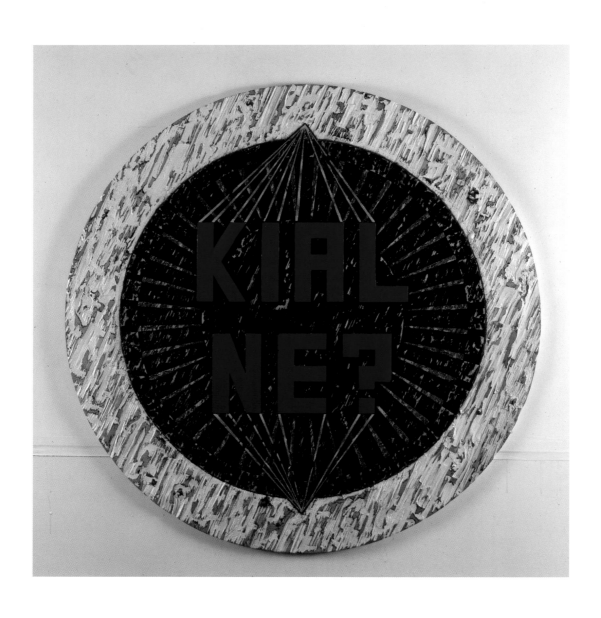

Kial Ne? 2002
carved wood, paint, 120 x 120 cm
Private Collection, London

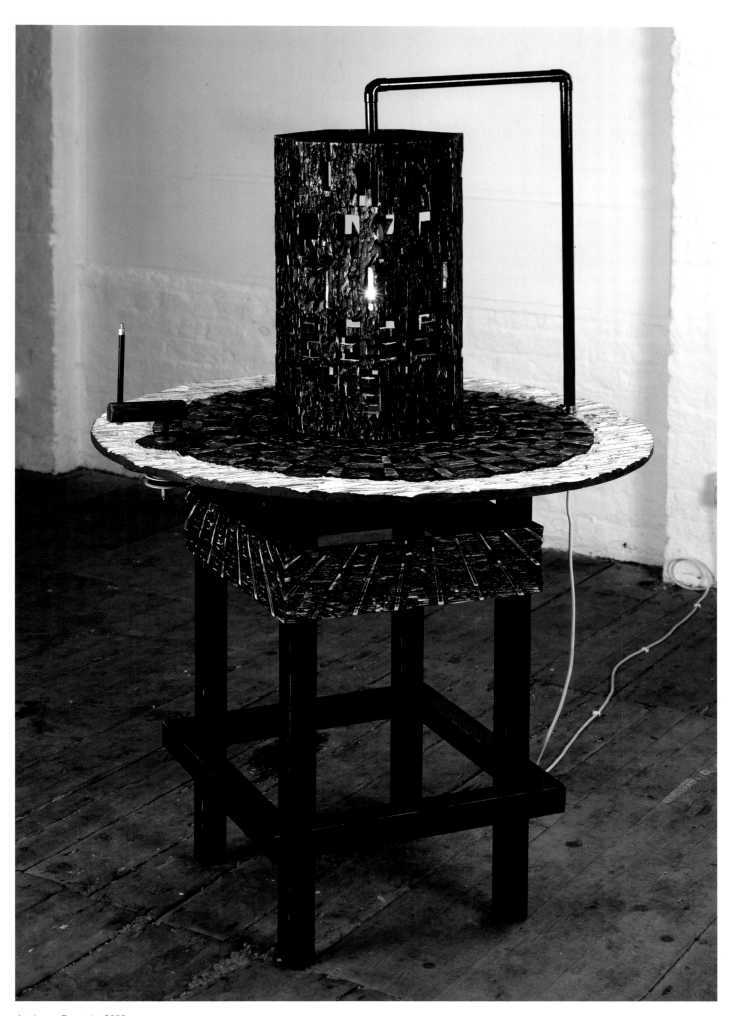

Analogue Fountain, 2003
carved wood, paint, light fittings, hand crank, 140 x 99 x 99 cm
Collection of Stephanie and John Rubeli, Los Angeles

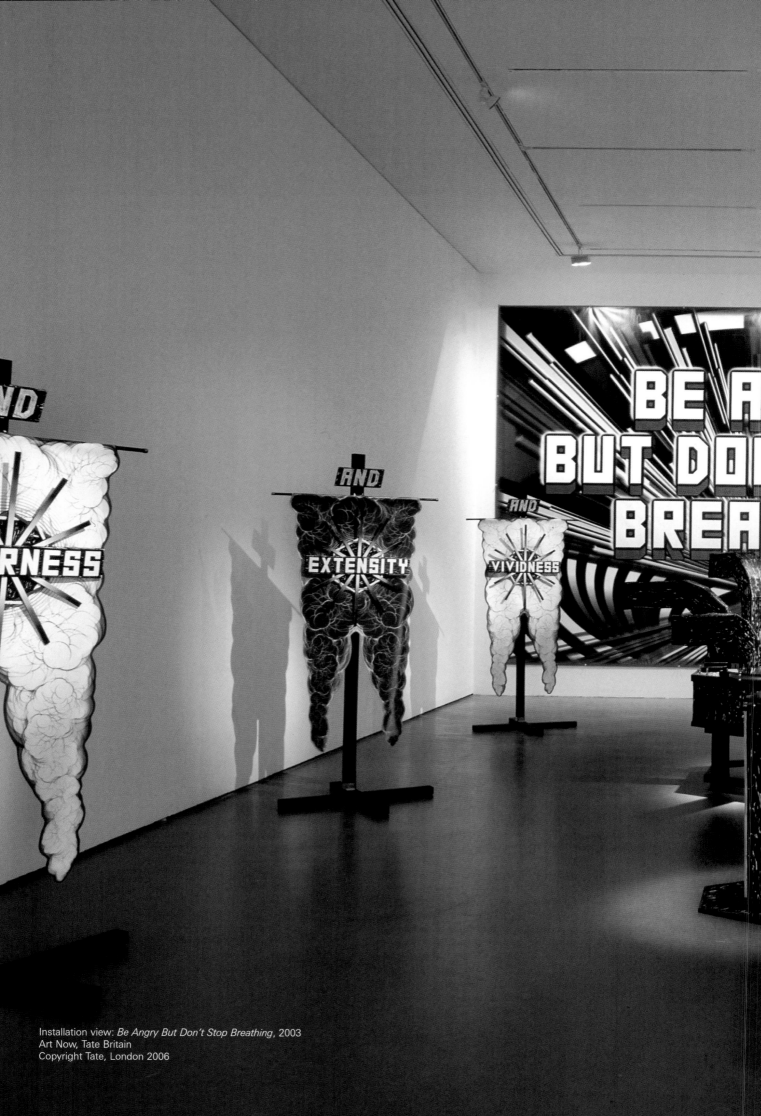

Installation view: *Be Angry But Don't Stop Breathing*, 2003
Art Now, Tate Britain
Copyright Tate, London 2006

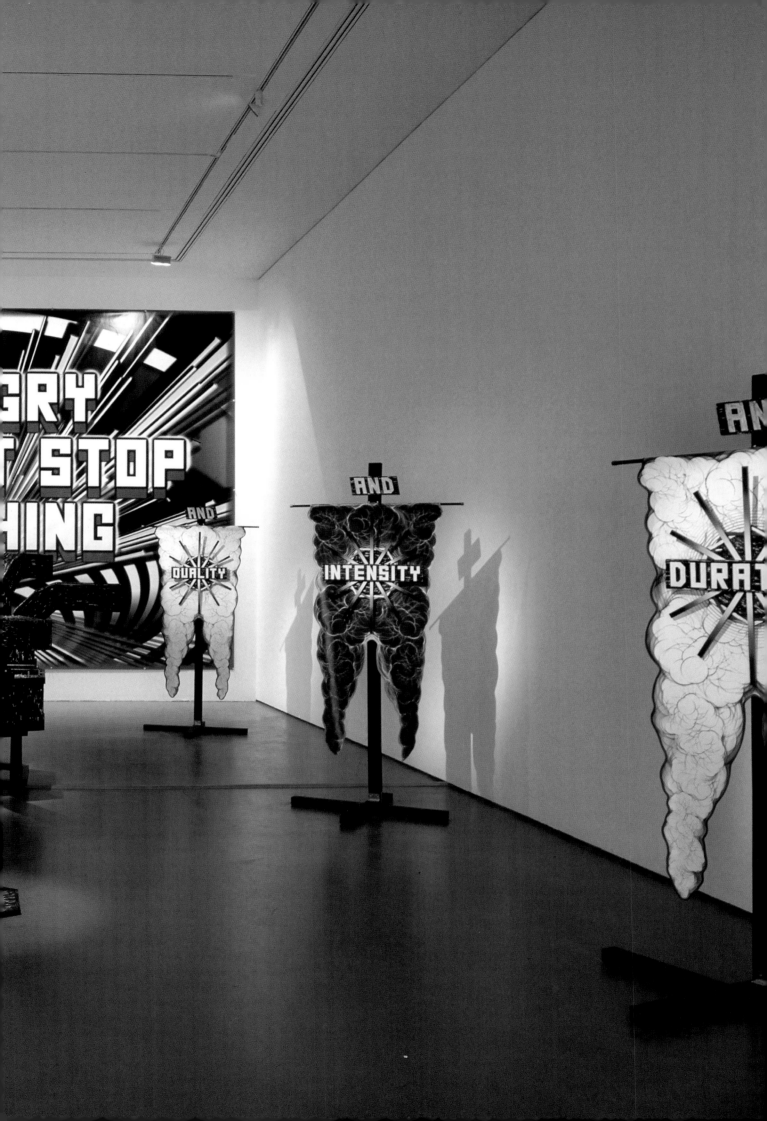

IF THE TRUTH CAN BE TOLD SO AS TO BE UNDERSTOOD IT WILL BE BELIEVED.

1. YOU ARE NOT ALONE. IN OUR SICK SOCIETY WE ARE ALL SICK.
2. THIS SICKNESS AND ITS CONSEQUENT TRAUMA IS COMPOUNDED BY THE ISOLATION OF THE INDIVIDUAL WITHIN THE TRAUMATISED WHOLE.
3. SIMPLE ACTS OF INTERACTION MAY BEGIN THE RECALIBRATION OF THIS RELATIONSHIP.
4. SO LET US BEGIN TODAY AND TOGETHER SING OUR FEARS.
5. LIBERATING OUR PRIMAL VOICE AND SHARING OUR TERROR.
6. LET US SING HUMANITY'S BIRTH SONG.
7. BY THIS ACTION WE RECALL THE VOICE THAT BECAME THE WORD.
8. THE PURE DESCRIPTION OF THE UNIVERSE THAT WE ALL CONTAIN.
9. TOGETHER IN THE QUIET MODULATION OF LIQUID WE GIVE FORM TO OUR FEARS.
10. WE ARE MATTER AND ALL MATTER VIBRATES.
11. BY THE OBSERVATION OF VIBRATION WE MAY LEARN SOMETHING OF OUR TRUE NATURE.
12. TOGETHER WE VIBRATE AND TOGETHER WE ARE ALONE.

IF THE TRUTH CAN BE TOLD SO AS TO BE UNDERSTOOD IT WILL BE BELIEVED.

1. [[YOU] EQUALS A PROPER SUBSET OF [EVERYONE]. FOR ALL ELEMENTS OF THE SET [EVERYONE], SICK EQUALS TRUE IF [ELEMENT OF [INTERSECTION [EVERYONE, SOCIETY]]] EQUALS TRUE] EQUALS A.

2. SICK IMPLIES TRAUMA IF [EXISTS ELEMENT OF THE SET INTERSECTION [EVERYONE, ISOLATED]] EQUALS B.

3. [EXISTS ELEMENT OF SET [INTERACTIONS] FOR WHICH SIMPLE EQUALS TRUE] IMPLIES NOT A AND/OR NOT B.

4. [EXISTS ELEMENT OF THE SET [EVERYONE [INTERSECTION [YOU, TODAY, SING, FEARS]]] EQUALS TRUE] EQUALS C.

5. C IMPLIES [EXISTS ELEMENT OF THE SET [EVERYONE [INTERSECTION [PRIMAL, VOICE, TERROR]]] EQUALS TRUE] EQUALS D.

6. D IMPLIES [FOR ALL ELEMENTS OF THE SET [INTERSECTION [HUMANITY, SING]], NOT [EXISTS ELEMENT OF SET [SING], OLDER EQUALS TRUE]] EQUALS E.

7. E IMPLIES [FOR ALL ELEMENTS OF THE SET [EVERYONE], VOICE EQUALS WORD].

8. EVERYONE IS A SUBSET OF EVERYTHING.

9. INTERSECTION [EVERYTHING, UNION [LIQUID, FORM, FEARS]] EQUALS QUIET MODULATION.

10. [FOR ALL ELEMENTS OF THE SET [EVERYONE], MATTER EQUALS TRUE] AND [FOR ALL ELEMENTS OF THE SET [MATTER], VIBRATE EQUALS TRUE].

11. IF [EXISTS ELEMENT OF SET [VIBRATE], OBSERVED EQUALS TRUE] IMPLIES [EXISTS ELEMENT OF SET [NATURE], TRUE EQUALS TRUE.

12. IF [UNION [VIBRATION, EVERYTHING] EQUALS TRUE] IMPLIES [YOU] EQUALS A SUBSET OF EVERYONE.

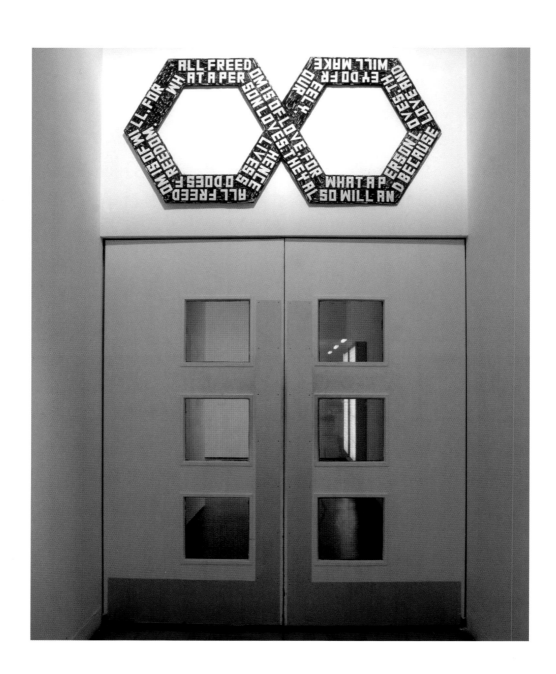

What Makes A Man Start Fires, 2003
Installation view: *Be Angry But Don't Stop Breathing*, 2003
Art Now, Tate Britain
The West Collection

Pg 42-43: *Be Angry But Don't Stop Breathing* (detail), 2003
two transparencies in lightboxes
diptych: each part 180 x 120 x 15 cm
Courtesy the artist and Vilma Gold, London

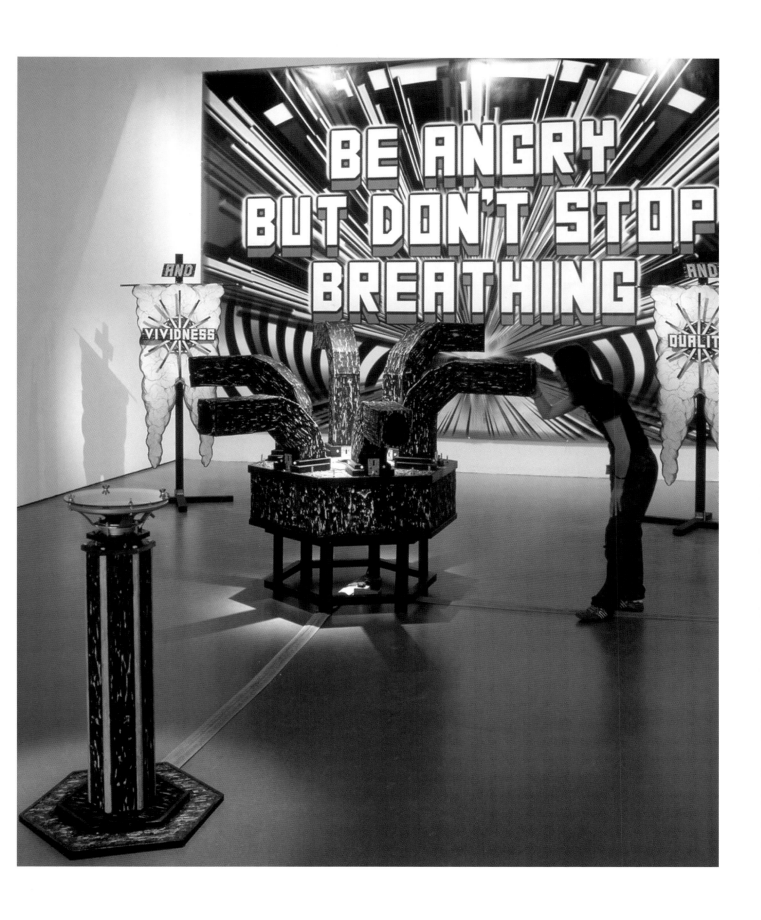

Installation view: *Be Angry But Don't Stop Breathing,* 2003
Art Now, Tate Britain
Copyright Tate, London, 2006

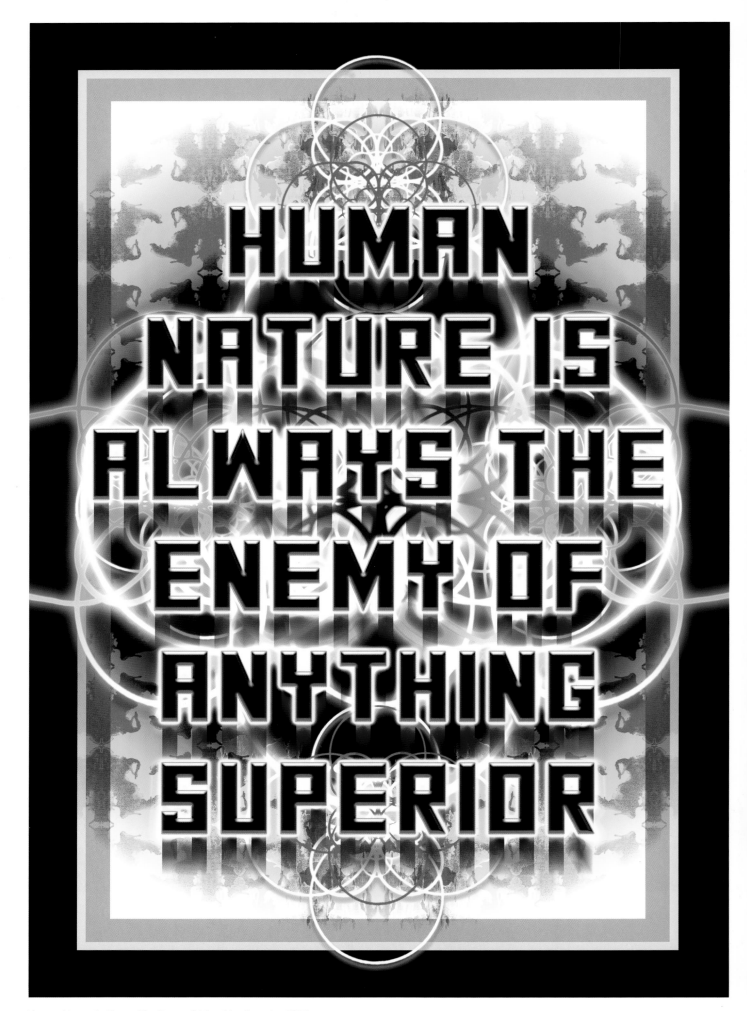

Human Nature Is Always The Enemy Of Anything Superior, 2005
digital print on diabond with carved wooden frame
194 x 134 x 3 cm, courtesy the artist and Vilma Gold, London

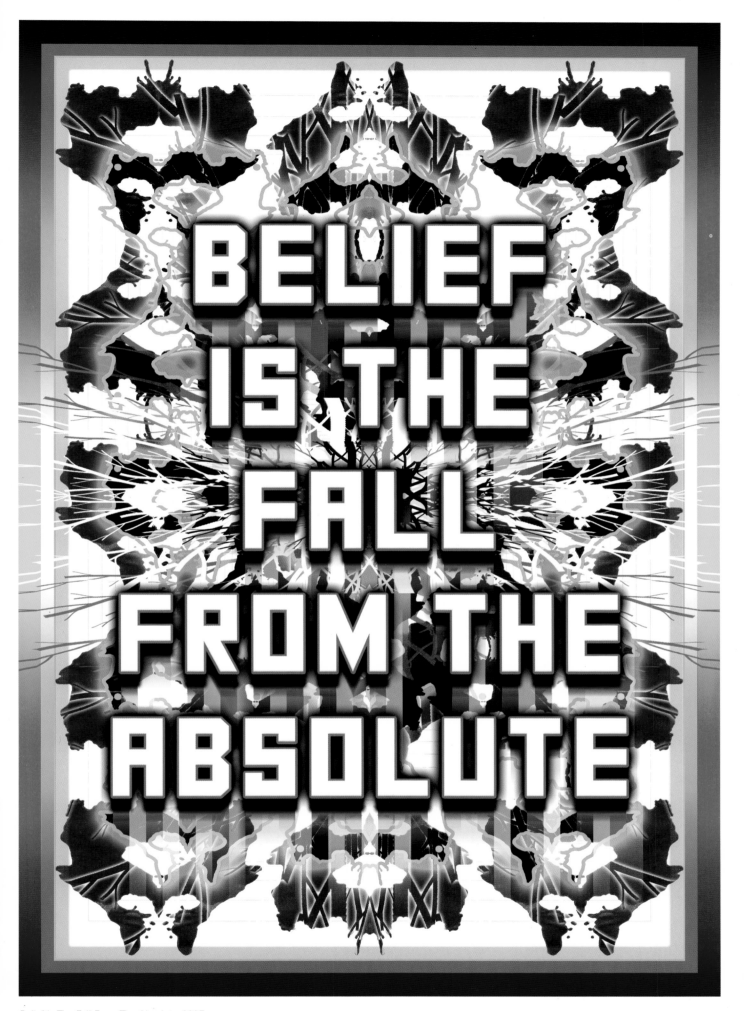

Belief Is The Fall From The Absolute, 2005
digital print on diabond, acrylic, carved wood
194 x 134 x 3 cm, Courtesy the artist and Vilma Gold, London

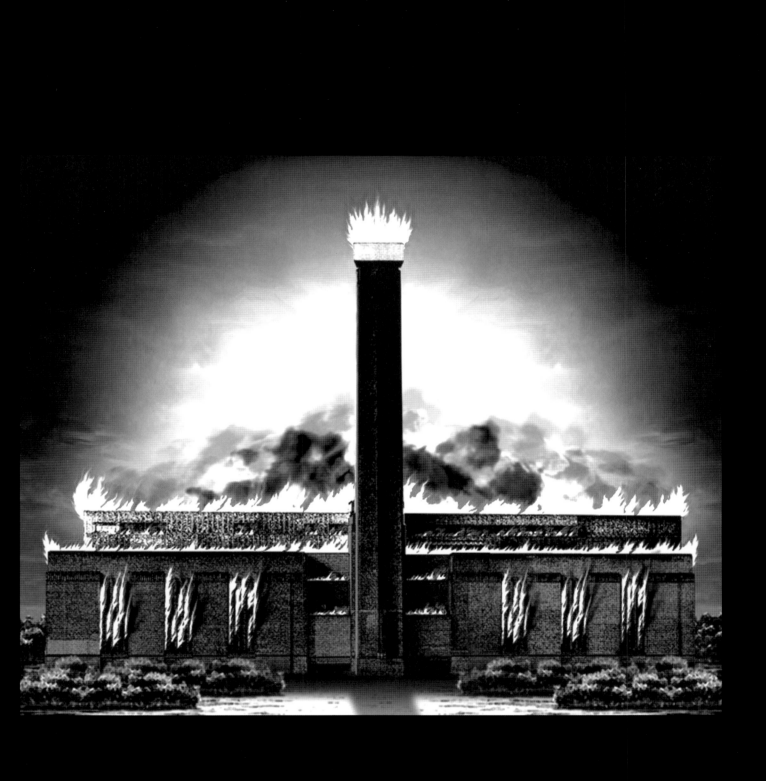

Still from DVD loop: *It Is You I Love The Most*, 2005
Courtesy the artist and Vilma Gold, London

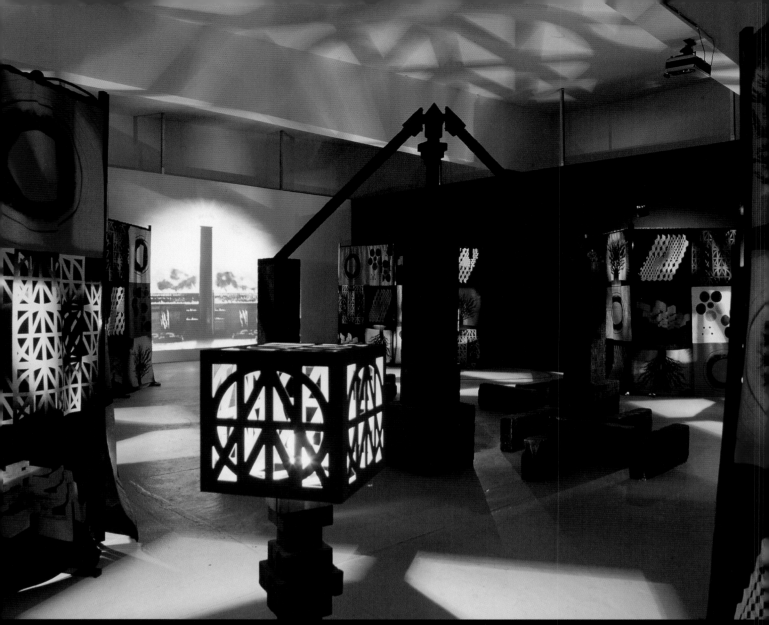

Installation view: *When We Build Let Us Think That We Build Forever*, 2005, Vilma Gold Project Space, Berlin
Courtesy the artist and Vilma Gold, London

EXEGESIS

WHEN WE BUILD LET US THINK THAT WE BUILD FOREVER

Maybe Plato got it wrong. Or perhaps, from a distance, he could not have known how grand illusions, when shaped by deft hands, can become true raptures of the mind, diamond-bright images of undying delight. Plato imagined an audience. Imprisoned in darkness. Chained by their own deceiving fascinations, they watch a parade of dancing shadows on a cave wall. The puppet-masters choreograph various forms lit by a fire that is the source of the audience's knowledge – that is the totality of their world. This world is not reality, but is merely a spectral representation. A benign hallucination. Plato's concern was that society, through the prolixity of images, would entirely dissociate itself from 'the real' and from Truth, or at least that this dissociation from the real would encourage the reign of anarchy. The importance of the allegory of the cave, in Book VII of *The Republic*, lies in Plato's belief that there are invisible truths beneath the apparent surface of things, truths that only the most enlightened can grasp.

Time becomes solvent. Everyone and everything is implicitly bound to grand narratives and specific ideologies. Exhausted political systems, tired revolutionary ideals and empty zealous doctrines mingle in a decisive provocation. Citations of traditions of western art are persistent and detailed – Suprematism colludes with iniquitous Symbolism while being distorted into something polytheistic. The geometric keystones of this universe are quite distinct from early-20th-century endeavours to discover the essence of pure shapes in the natural world.

In *It is you I love the most* (2005) we are confronted by a highly stylised rendering of Tate Modern. The former power station radiates a brooding apocalyptic glow. The art institution flares with billowing smoke, literally overheating with Titchner's malevolent aesthetic. The looped clip pulsates to a crescendo, flickering and flashing before starting the process over. This is a lodestone image communicating through visual Morse code. It is echoed in two smaller projections housed within the singular viewing spaces of the encircling screens. The first takes us inside the Turbine Hall as it appears to slowly melt, from frame to frame, while the second takes flight via a computer-aided architectural fly-round of the burning building. Reaching for immediate associations, we confront Ed Ruscha: *Los Angeles County Museum on Fire* (1969-70) presents us with a cinematic viewpoint – panning from lower right to upper left – from which to witness the hypothetical demise of the much-criticised museum. Like an architectural model, the painting has an oblique, aerial vantage point akin to an establishing shot. Early in his career Ruscha made films – such as *Miracle* (1975) – and he has incorporated a number of cineaste references in his canvases, from the exquisite monochromatic numbered seconds of a film leader in *9, 8, 7, 6* (1991) to the cinematic *The End* (1994), painted with the flourishing signage of the studios

Top: Ed Ruscha, *Museum on Fire #1*, 1968 powdered graphite on paper 20.3 x 37.5 cm

Bottom: Ed Ruscha, *Study for the Los Angeles County Museum on Fire (museum study #2)*, 1968 gunpowder and graphite on paper 19.4 x 37 cm

and signalling the cinemagoer's return to the *real* world. Titchner deconstructs film to create a spatial frame that is perhaps more architectural or experimental. Something that is not so secure within the safety of the screen. Something more cinematically clandestine. Theodore Roszak's novel, *Flicker* (1980), is a sweeping conspiracy that ties the history of film and early Christian mystery cults to the deist freemasonry of Thomas Edison. Subtract the plotline of world occult machinations and the book is a disturbing exploration of the meaning and effect of representation. At its core is the persistence of vision. This is the peculiar ability of the human mind to create a fusion of apparent motion from a series of static images. From the Laterna Magica, zoetrope, and kinetoscope through to the Lumiére brothers, an array of optical inventions were created to animate images in rapid succession to produce illusion. Film, at its most basic, is a portrayal of the eternal battle between light and dark, independent of its actual content. To create this illusion there must be an imperceptible gap between each image – a flicker. What if we employed the flicker to say 'something', to speak to the audience without words or narrative; a way of harnessing form or material to attain the capacity to work on the audience in a purely aesthetic way? All film, Roszak argues, is secret film. Filled with hidden agendas and manipulative designs upon our psyches. It is a conspiracy against the real. Film is not real, but it tries to tell us that it is, and our own sense of reality suffers a bit each time we walk into the darkness of the cinema. In turn this has effected a fragmentation of our field of vision. It has inaugurated new kinds of spaces and new forms of psychological and sensory experiences of space, characterised by plurality and contradiction, proximity and isolation. Film has developed a language, cut and spliced, commensurate with the increasing spatial complexity, temporal indeterminacy and social dynamism of the modern world. It has forged an individual and collective psychological space merging with new forms of social relations and subjectivities. In his essay on the new cinema theatres of Berlin, *The Cult of Distraction* (1926), Siegfried Kracauer described the theatres as 'a total artwork [*Gesamtkunstwerk*] of effects… that assaults the senses using every possible means'.

Kracauer's analysis of cinema's cognitive functions predicated distraction as a social and aesthetic strategy within modern spectacular society. Titchner draws a similar analogy with the absorption of utopian avant-garde ideals into mainstream culture. In previous work, such as his wall drawing *The final times have been and gone* (1999) the resonance of Albers and Vasarely is consumed through pattern, taste and decor. Modernist aesthetics collapse, detached from their ideology, emptied of their politics, free to become the backdrop to our domestic environments. In *When we build…* Titchner extracts this all-encompassing experience in the production of an entirely different politicised environment.

Six arcane images recur across the folds of the drapes that screen discrete spaces within the installation. The designs replicate a foreboding pedagogy of elements – a backlit bush, an optical flower puzzle, concentric circles and abstract geometry. Printed in menacing red, white and black, they imbricate avant-garde idealism. Architecturally, the screens set a stage for both public and private scrutiny. In some instances they operate internally as individual projection booths, while others demarcate a restricted space. The source of their fabrication stems from the unwritten conspiratorial

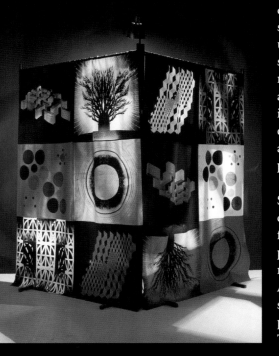

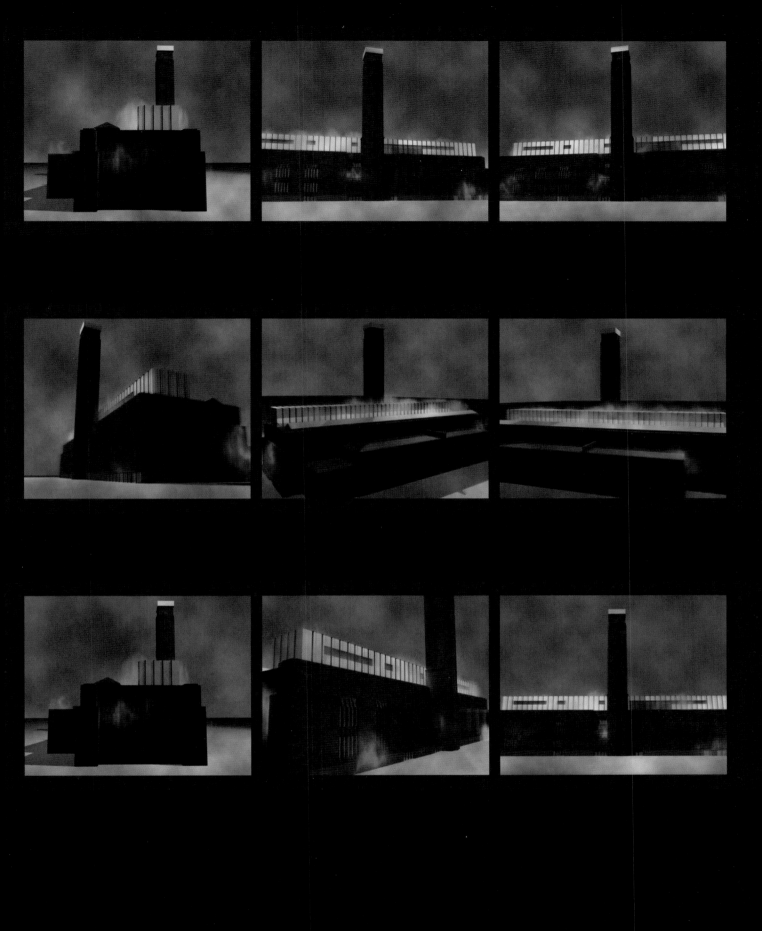

Stills from DVD loop: *When We Build Let Us Think That
We Build Forever*, 2005
Courtesy the artist and Vilma Gold, London

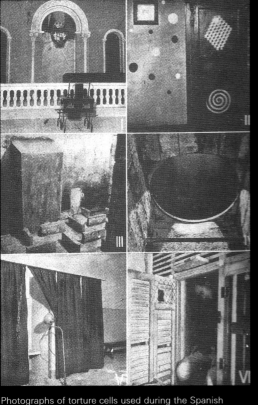

Photographs of torture cells used during the Spanish
Civil War

history of modernism. The Bauhaus, Kandinsky, Klee, Moholy-Nagy
and the surrealist films of Buñuel all colluded to inspire anarchist
Alphonse Laurencic during the Spanish civil war. Laurencic, a painter
turned architect, invented a form of 'psychotechnic torture' as a
contribution to the fight against General Franco's rightwing rebel
forces. The torture cells built in 1938 applied avant-garde theories on
the psychological properties of colour and geometric abstraction.
The series of six-foot secret cells was designed to distress, confuse and
disorientate the prisoners. Furniture was placed at implausible angles
while the floors were scattered with bricks and irregular geometric
forms to prevent detainees pacing back and forth. The only option left
to the prisoner was to stare at the walls. These, in turn, were curved,
painted with geometric forms, and utilised perspective and modifica-
tions of scale to increase mental anguish. Erratic lighting effects
accentuated the abrasive and frenetic decoration. Some cells were
painted with tar to send the temperature soaring in the sun and to
produce asphyxiating heat. Modernism's ability to shock the conven-
tional sensibilities is well documented and an evident function within
art. Torture is almost too predictable an extension of a culture of
provocation. Laurencic's usage of the progressive technocratic forces
of modernism for nefarious and repressive means perhaps reveals how
easily culture finds itself seduced by barbarism.

Titchner restages in fragments the cannibalisation of revolutionary
and liberating artistic languages. He draws on these covert reference
points in a renegotiation with the progressive spirit of modernism.
Art can be an instrument for transforming the larger culture - in the
right hands. There is an overt recognition within Titchner's work that
knowledge and power are inextricably bound. They are situated
amongst a cacophony of social practices and situations. Through the
excavation of referential discourses an estranged epistemology is
forged. Rewinding to Plato's allegory of the cave, we recall that those
who cast the shadows have the power to project certain intentionality,
through the formation of the icons paraded in front of the fire. One
interpretation of the allegory is that Plato's puppeteers are institutions
and authorities that manipulate how we apprehend the world. The
museum still dominates the horizon of our material culture,
legitimising cultural form and expression. Its practices of selection,
presentation and historiography deploy values that control and
decipher our past. These governing practices – the ruling forces of
political and economic factors – reveal the institution as subject to the
shifting associations of authority. In Titchner's manifestation we
confront institutions head on. Is this an infernal critique? The
museum's position as the most authoritative art institution appears
inflamed. Is this fire a metaphor for knowledge, or internal combus-
tion, brought about by the weight of governing the construction of
our present, as well as our hallucinatory future?

At the heart of the exhibition we encounter another razed infernal
depiction exhorted in material form. A dark structure is fashioned in
lumpen blocked wood and stone; the entirety of the charred form
holds ruinous script. Amongst the cool resolution of projections and
digitally rendered sound and imagery, this sculpture possesses a
resolutely physical matrix. Four roughly hewn pillars meet and outline
a pyramid. From the apex of the pyramid hangs a geometric
representation of the biblical burning bush. It is a three-dimensional
realisation that alludes to Mondrian and Malevich but is fuelled with

the intent of an outsider's craft. This formation is a theatrical setting for the spiritual paradox that is Moses' biblical encounter. Moses knelt like a humble scholar in pursuit of enlightenment. The bush burnt without being consumed. Fire is, again, knowledge. The divine communiqué emitted describes not the essence of things but a certain perception that affects our earthly reality. A linguistic endgame, wherein to name something is to define it.

Titchner's use of language, as Michael Wilson writes in his *Artforum* review of *Why and Why Not?* (2004), is 'a kind of alienated, under-mined, institutional poetic… [he] summons declarative force only to cast profound doubt on the authority of any given creed.' In *When we build…* Titchner literally hammers alternating texts into the supporting columns of the central sculpture. WHAT IS THIS SHADE, THIS DARKNESS THAT MOCKS US WITH THE SIGHT OF WHAT WE MIGHT HAVE KNOWN and HERE I AM, A LIGHT FLASHING ABOUT YOU OF ALL PEOPLE, IT IS YOU I LOVE THE MOST are just two contrapuntal examples that articulate a physical penumbra. There is no simple exegesis of Titchner's use of quotation and language. At times it is scholastic and measured. At other times his composite citations read like zealous rants. This is reflected in their textual references and allusions: from Spinoza and Blake to the narcotic philosophy of Philip K Dick and the lyrics of The Fall. No single source is privileged above the other. Everything and everyone is eclipsed towards enlightenment.

Both The Bible and Plato's *Republic* are concerned with man's search for the infinite and metaphysical truth that will provide a moral structure for society and its institutions. It is not possible to turn the eye from darkness to light without turning the whole body. To prolong our Platonic analogy, we must escape the bonds of the cave, transcend the shadows and emerge into the sunlight and knowledge of true forms. At no point in his work does Titchner propose such a route, or cast judgement on the material proffered. Instead the scenario is confounded. Throughout the exhibition, a visionary agency is at work without divulging any clear or explicit knowledge. Philip K Dick's gnostic vision is documented in his amphetamine-fuelled *Valis* (1981), in which a coterie of religious seekers forms to explore revelatory visions. The group's hermeneutical research leads to a rock musician's estate where they confront the Messiah. Titchner paraphrases Dick's heavily autobiographical epiphany, in which the prophet Elijah possesses him in the form of a rose-coloured light. Dick believed his enlightenment was an act of love. He was unable to rationalise his experience, questioning his perception of reality. He transcribed what thoughts he could into an eight-thousand-page, million-word journal, written in the first and third person, laced with paranoia and arboreal fantasies. Maybe the moral here is this: if we returned to the cave knowing the truth, our eyes would be slow to adjust to the dim light. Visionaries, by their nature, are not appreciated and often misunderstood. Rarely do they drag the rest of the dark cave's inhabitants to light and knowledge. Like rock stars, they either burn bright or burn out.

With our visionary light extinguished we turn to Spinoza, whose devaluation of sense perception as a means of acquiring knowledge, description of a purely intellectual form of cognition, and idealisation of geometry as a model of philosophy all make him, at first, a

Still from *Un Chien Andalou*, 1929

seemingly odd presence within Titchner's schema of reference. But Titchner appropriates Spinoza's monistic proposition. LIGHT I.E. REALITY I.E. NATURE I.E. LIGHT (and so on) identifies divinity and nature as one and the same while conflating creator and creation. Later, in his ethical writings Spinoza warns us of 'affects'. Life under the sway of affects is a life of bondage. He identifies the key passive affect – desire. Desire is a result of external causes acting upon the mind and motivated by perseverance – insofar as the mind is conscious. Because all passions are derived from this primary affect, the entire 'passional' life of the mind strives towards inadequate ideas.

Conscious and unconscious desire pervades *When we build…* through Titchner's use of sound and, additionally, from four specific sources of light. Punctuating the gallery space at irregular intervals Titchner introduces freestanding sensorineural lamps that filter a sodium glow through angular forms. They cast illuminating shadows. The seemingly innocuous designs belie the incantation of their configuration. They are sigils. Ritualistic glyphs devised through the reduction of alphabetical characters, planetary squares or Enochian tables into a single seal. Sigils mobilise our unconscious towards accomplishing the desires of the conscious mind. Desire. Need. Want. The intensity of these affects governs the power the symbol will hold. Titchner draws this practice from a marginal cultural figure - Austin Osman Spare. Spare flirted with the avant-garde of London at the beginning of the 20th century, exhibiting his drawings of grotesquely sexualised figures. An official war artist, he renounced his success in the pursuit of the occult and seclusion, contributing drawings to Aleister Crowley's publications. Spare simplified magic to the drawing of sigils, charging his designs through visualisation towards a state of gnosis. After internalisation, Spare instructed that the symbol should be displayed before its destruction by fire.

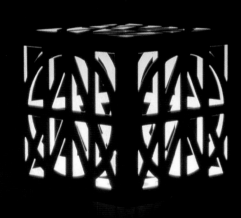

Installation view: *When We Build Let Us Think That We Build Forever,* 2005, Vilma Gold Project Space, Berlin Courtesy the artist and Vilma Gold, London

Titchner's sigils are evocations held in permanent stasis, their forces suspended through exhibition. Their display is subconsciously internalised by the viewer. (As part of *British Art Show 6*, Titchner generated a series of sigils that adorned billboards throughout Newcastle. The statements of intent and desire were based on requests made to local authorities by the public.) In Titchner's hands, this esoteric process elucidates his enquiry into the power of representation. It is mapped onto a persistent questioning that – from the psychotechnic cells of Laurencic to the film of the emblazoned museum – is revealed throughout the exhibition. Unbeknownst to the viewer, the demand cast in the ruinous symbols refrains in the subliminality of the accompanying sound - 'Show us things as they truly are.'

Contiguous with the way Titchner mines object, image or text, he also manipulates, collages and distorts sound. Drawn from the last movement of Beethoven's Fifth Symphony, the first few notes of the opening fanfare are stretched to the length of the entire movement. Layered into these harmonics are two almost inaudible voices. They are digital pronouncements that repeat the breathless mantra of the sigils. Titchner's selection of this specific Beethoven symphony is referentially significant. It is the very movement that colludes with an extreme filmic montage in a fictional aversion therapy, the Ludovico Technique. In Anthony Burgess' novel *Clockwork Orange* the procedure is employed to cure the antisocial young gang leader Alex. Alex himself refutes the argument that ethical good has any relationship to aesthetic good. He comments on a newspaper article that proposes moralising London's youth through the fine arts. Alex has a refined taste in classical music, particularly 'Ludwig van', but the music only riles him to violence. When this music becomes associated, through the Ludovico Technique, with immorality, Burgess demonstrates the utter malleability of aesthetics and ethics.

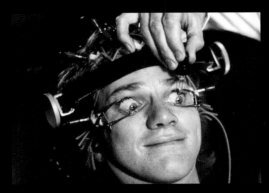

Still from *A Clockwork Orange*, 1971

Archaeologically excavating the references and intertextuality of Titchner's exhibition reveals a continuously discursive formation. In a moment of clarity, and due to the contiguous nature of the totalising installation perhaps, we apprehend a moment of acuity. A fleeting episteme. Titchner charts a historic migration where the aestheticisation of politics is countered by the politicisation of aesthetics. His arrangements of signs inhere to both reality and representation. Ideologies, belief and knowledge coagulate, less as rigid convictions than as vehicles for speculative thinking. In *The Nights of Labour* (1981), philosopher Jacques Rancière chronicles accounts of the self-education of the artisan classes during the 19th century. He implicitly states that we can forge a 'society of emancipated individuals that would be a society of artists,' who would 'repudiate the divide between those who know and those who don't know'. It would recognise only 'active minds that speak of their actions and transform all their works'. Mark Titchner's 'works' within such an aesthetic regime clearly envision how art can be historically affective and directly political. He achieves this by means of fictions: Fictions in which history, culture and politics flicker into an unfinished film, a documentary fiction, of which we are both cameramen and actors.

Alun Rowlands

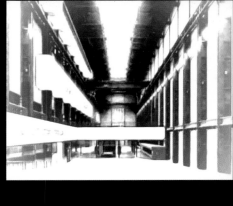
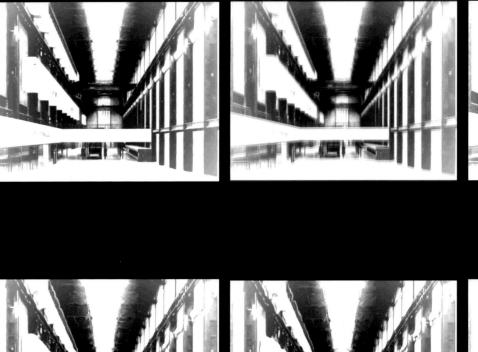
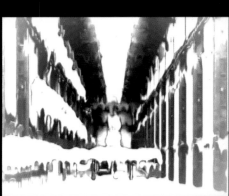
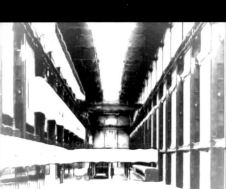
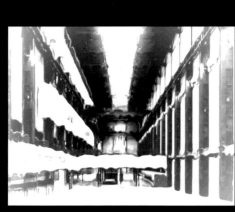
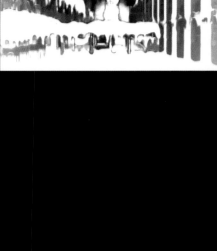
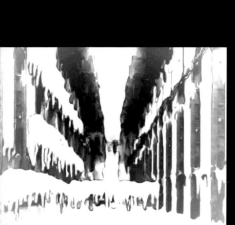
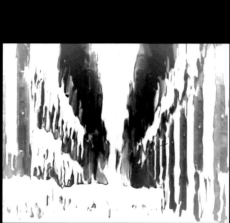

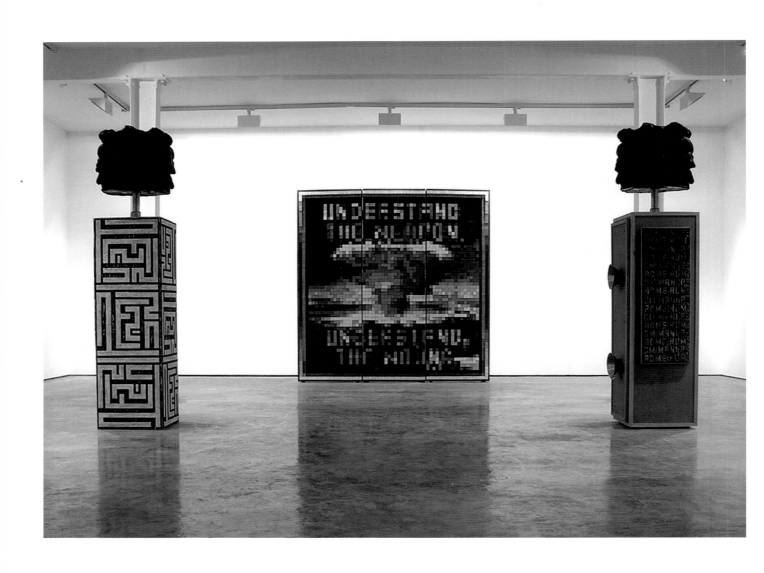

Installation view: *20th Century Man*, 2004
Vilma Gold, London
Courtesy the artist and Vilma Gold, London

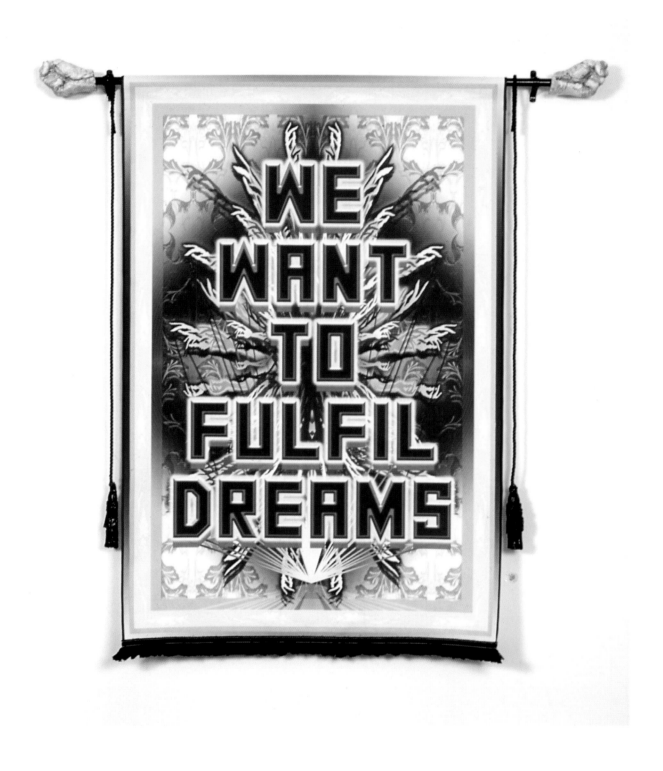

We Want To Fulfil Dreams, 2004
inkjet print on canvas, metal, plaster, resin, trimming
160 x 150 x 10 cm
Private Collection, The Netherlands

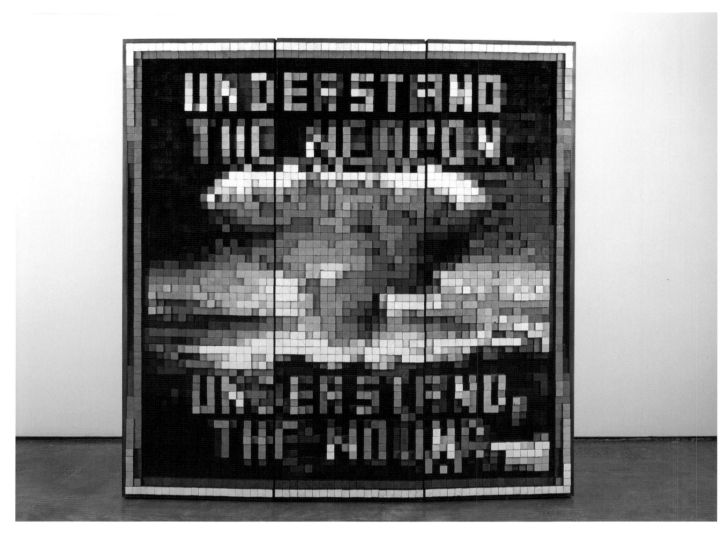

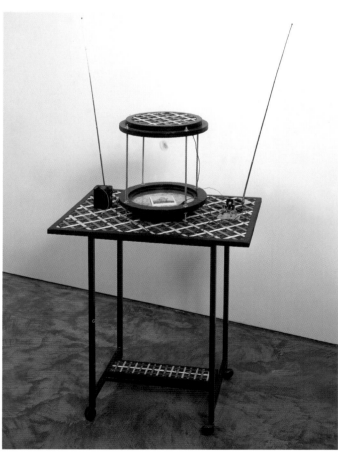

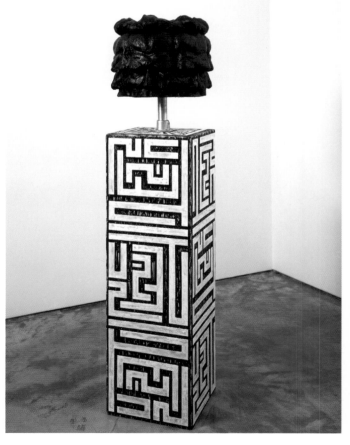

(When You Can Say Anything) What Is There Left To Say?, 2004
metal stand, wheels, electrical transmitter, copper, wood, paint, battery,
Polaroid, 156 x 48 x 87 cm, courtesy the artist and Vilma Gold, London

20th Century Man (JC), 2004
wood, paint, rubber, wax, metal 125 x 41 x 41 cm
Courtesy the artist and Vilma Gold, London

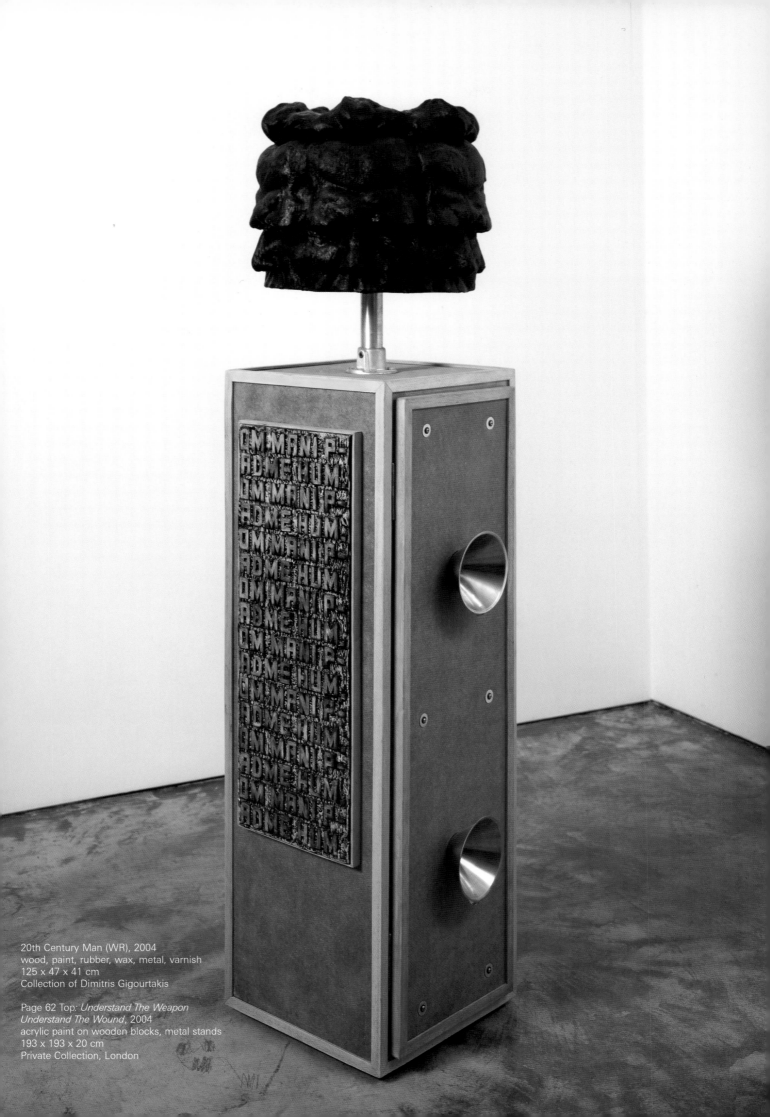

20th Century Man (WR), 2004
wood, paint, rubber, wax, metal, varnish
125 x 47 x 41 cm
Collection of Dimitris Gigourtakis

Page 62 Top: *Understand The Weapon
Understand The Wound*, 2004
acrylic paint on wooden blocks, metal stands
193 x 193 x 20 cm
Private Collection, London

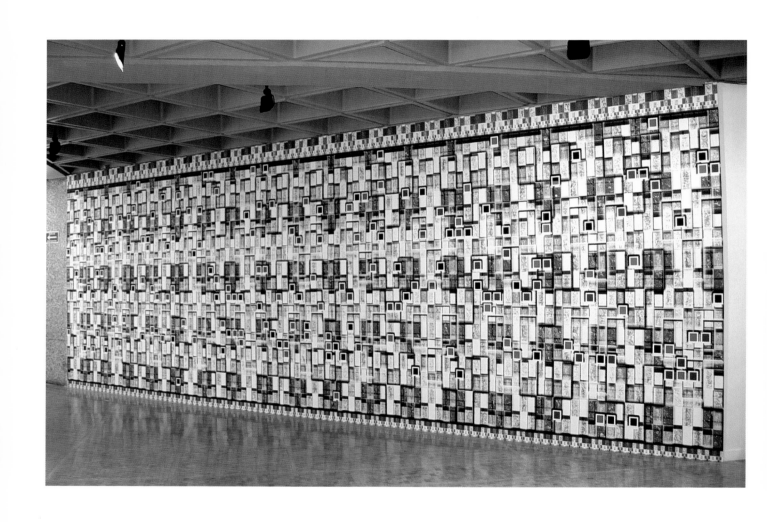

Above: *Y And Y Not?,* 2004
digital print on paper
Courtesy the artist and Vilma Gold, London
Commissioned by the British Council for the exhibition
Sodium and Asphalt, Mexico

Opposite: *?Por Que Hay Algo En Lugar De Nada?,* 2004
Courtesy the artist and Vilma Gold, London
Commissioned by the British Council for the exhibition
Sodium and Asphalt, Mexico

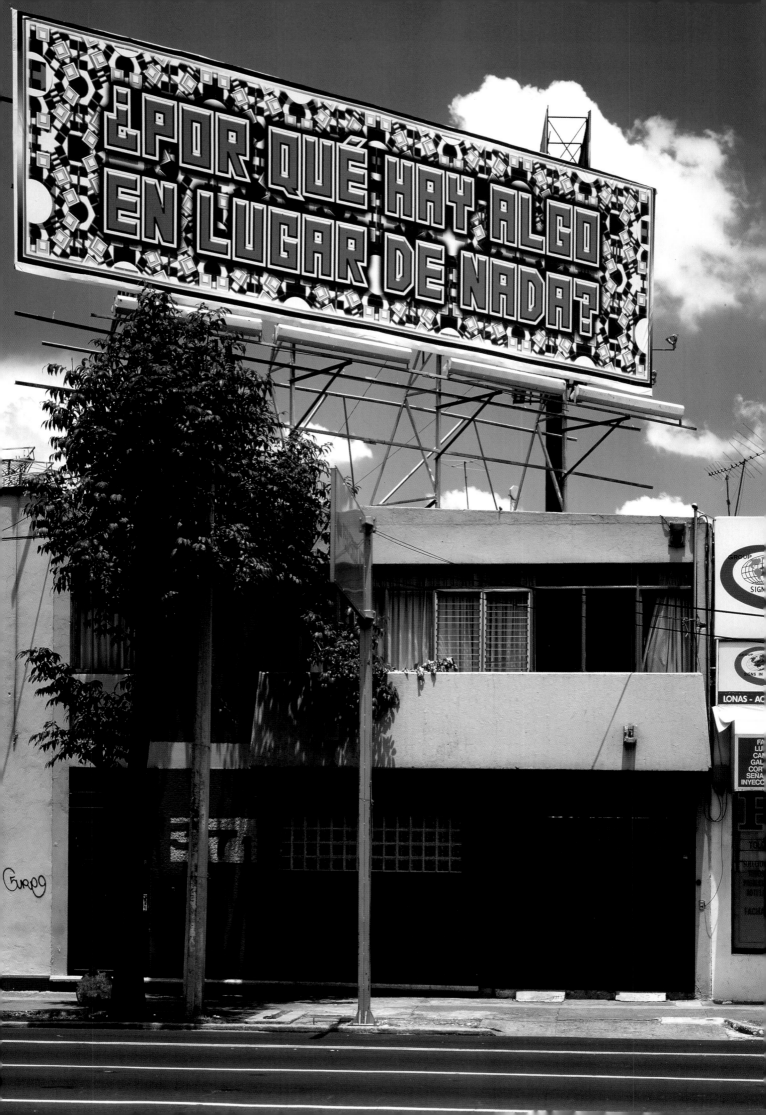

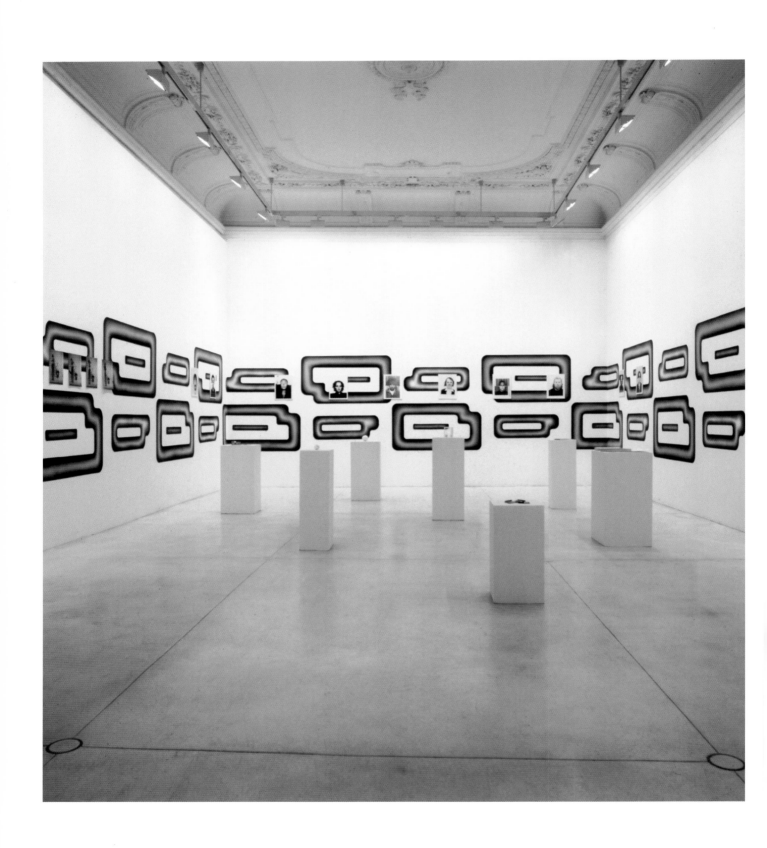

Why Is There Something Instead Of Nothing?, 1999
sprayed emulsion on wall, dimensions variable
Installation view: *Limit Less*, 1999, Galerie Krinzinger, Vienna
Courtesy the artist and Vilma Gold, London

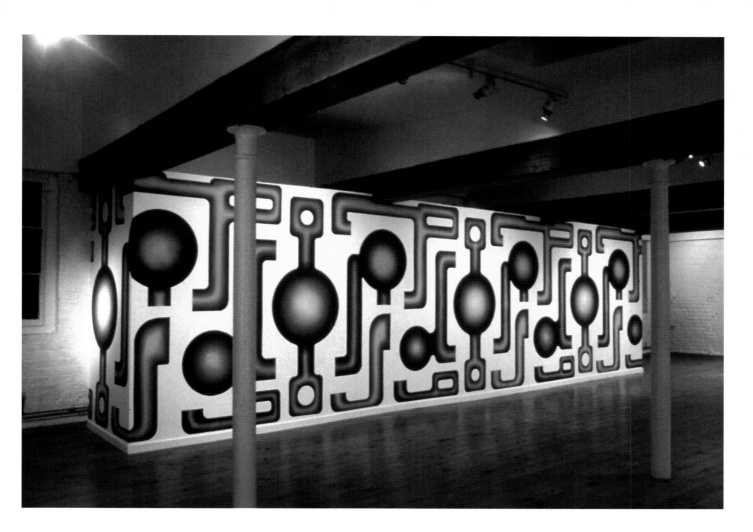

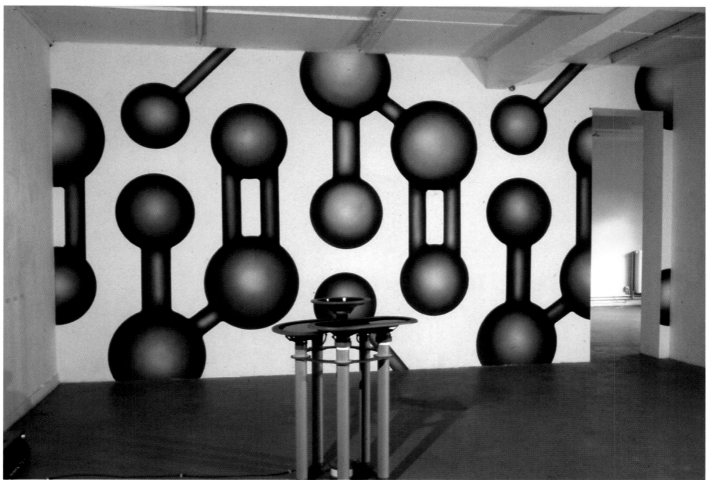

Top: *The Final Times Have Been And Gone*, 1999
sprayed emulsion on wall, dimensions variable
Courtesy the artist and Vilma Gold, London

Bottom: *Why Is There Something Instead Of Nothing?*, 2000
sprayed emulsion on wall, dimensions variable
Courtesy the artist and Vilma Gold, London

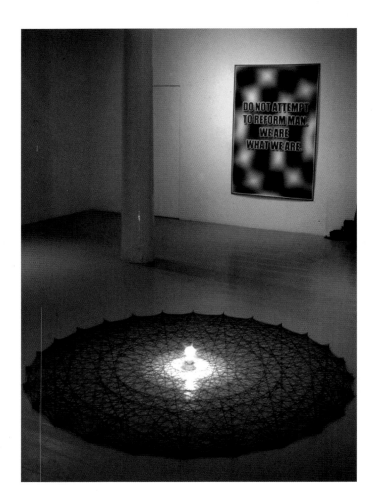

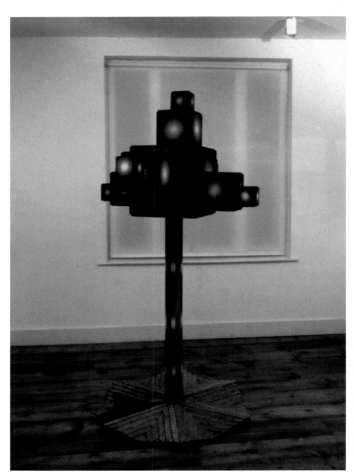

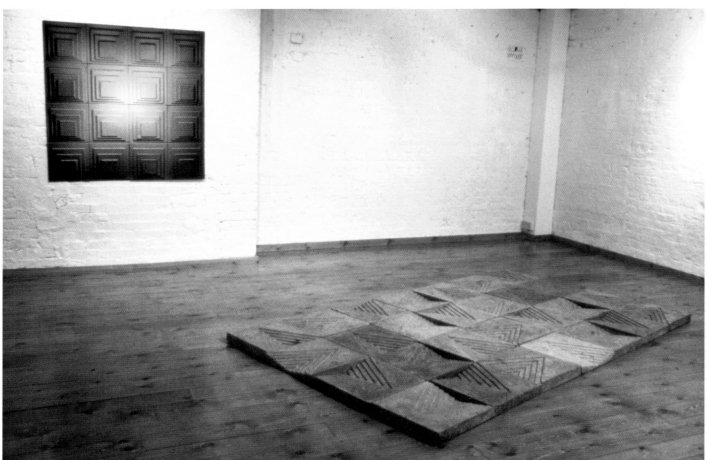

Top left: *The Universe Is The Interior Of The Lightcone Of Creation*, 2001
wool, nails, daylight bulb, 15 x 160 x 160 cm
Installation view: *Best Eagle*, 2001
Transmission Gallery, Glasgow
Courtesy the artist and Vilma Gold, London

Top right: *Trees Against Boys*, 2000
concrete, plastic, polystyrene, wood, paint
200 x 60 x 60 cm
Courtesy the artist and Vilma Gold, London

Bottom: From left: *Homage To The Squares*,1999
polystyrene tiles, paint, 120 x 120 x 5 cm
Courtesy the artist and Vilma Gold, London
Concrete, 1999
cast concrete, 10 x 160 x 280 cm
Private Collection, London

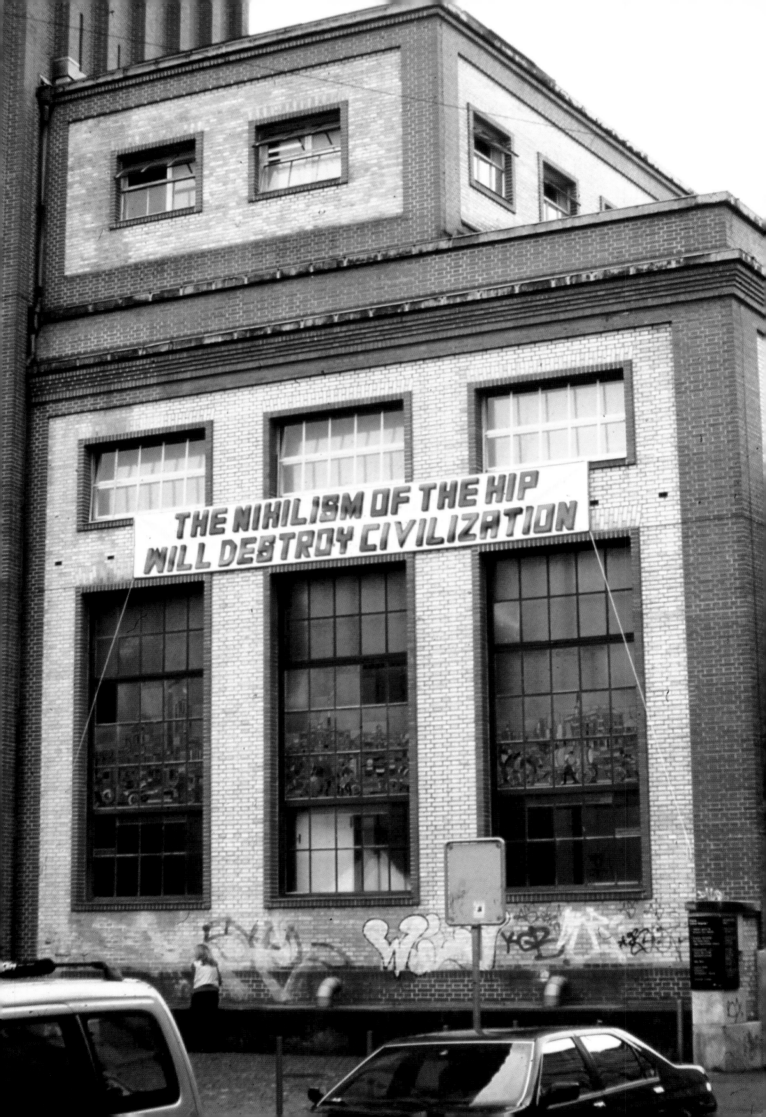

Tattoo, Photo: Richard Adamson

Page 69, Installation view:
The Nihilism Of The Hip Will Destroy Civilization, 2002
Liste Young Art Fair, Basel
Courtesy the artist and Vilma Gold, London
Commissioned by the British Council, Switzerland

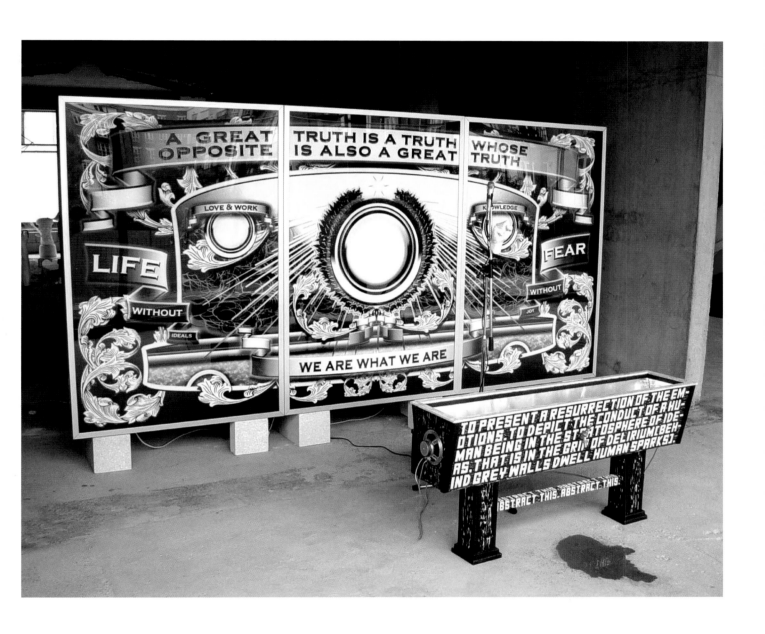

The Memory Of Our Will Will Wash The Dirt From Your Feet, 2003
lightboxes, carved wood, metal, concrete, amplifier,
microphone, water, speakers, 185 x 351 x 30 cm
Courtesy the artist and Vilma Gold, London

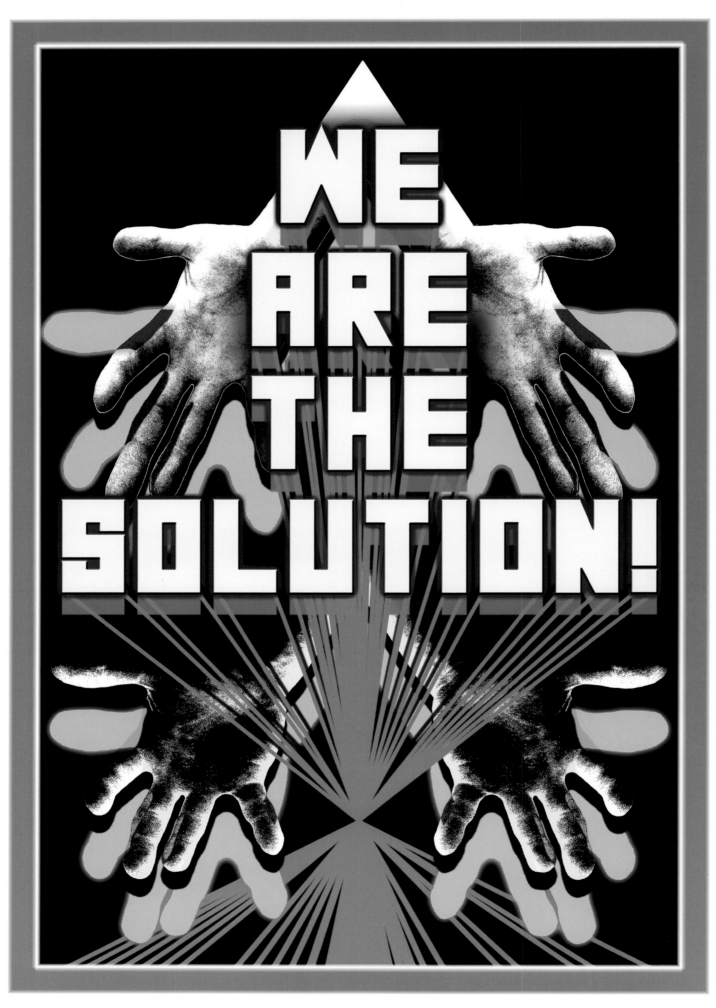

We Are The Solution, 2003
transparency in lightbox, 150 x 100 x 15 cm
Private Collection, The Netherlands

Opposite: *Voices You Cannot Hear Tell You What To Do (edit)*, 2004/2006
59th Minute commission, Times Square, New York
Rosetta Collection, Amsterdam

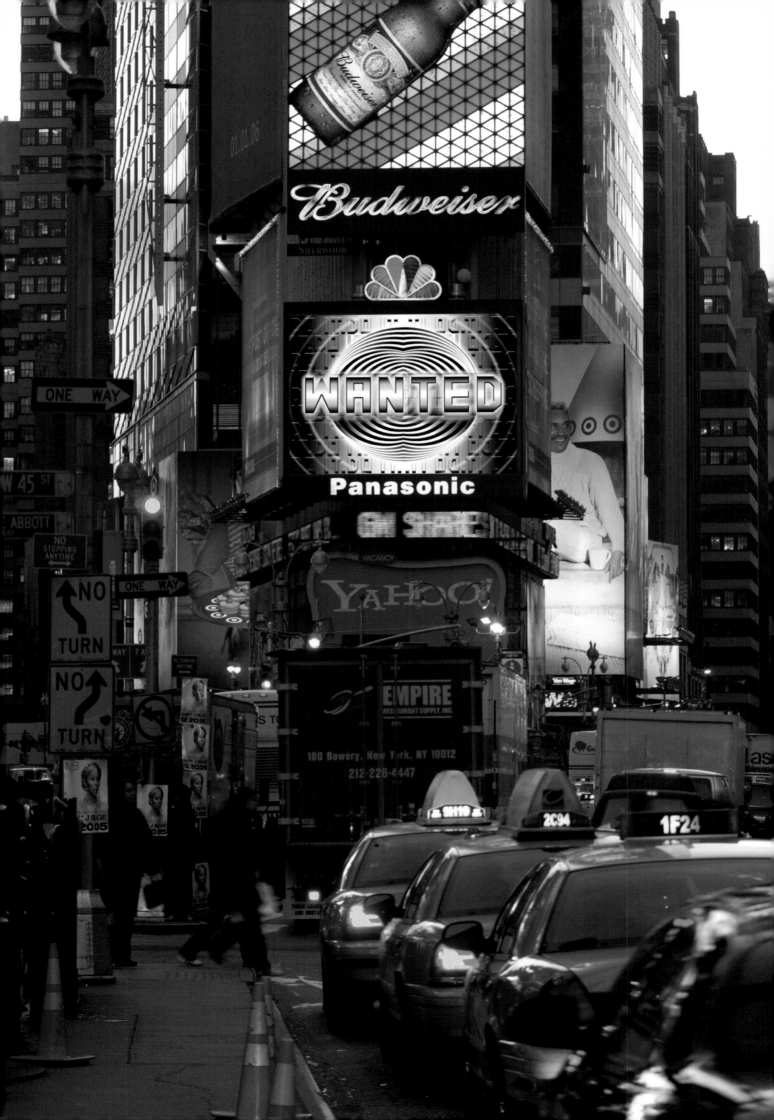

EVERYTHING I MET BEAUTIFUL

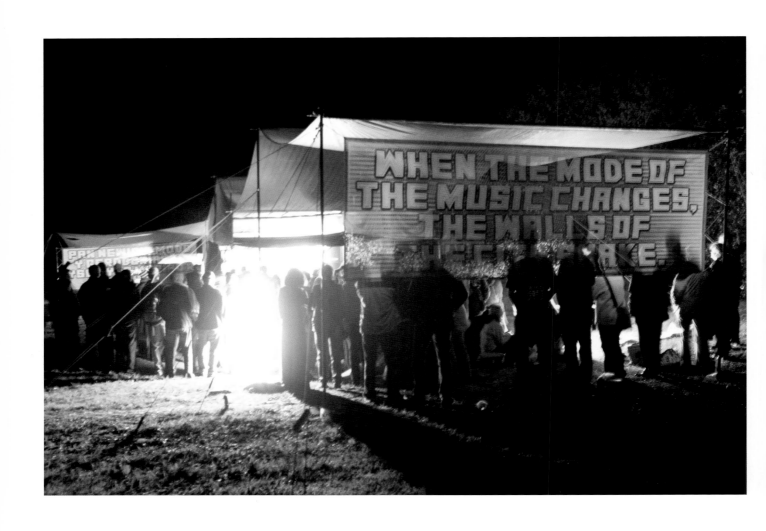

*When The Mode Of The Music Changes, The Walls Of The City
Shake*, 2003, printed banner
Installation view: *Roadshow,* 2003, Grizedale Forest
Courtesy the artist and Vilma Gold, London
Commissioned by Grizedale Arts
Photo: Polly Braden

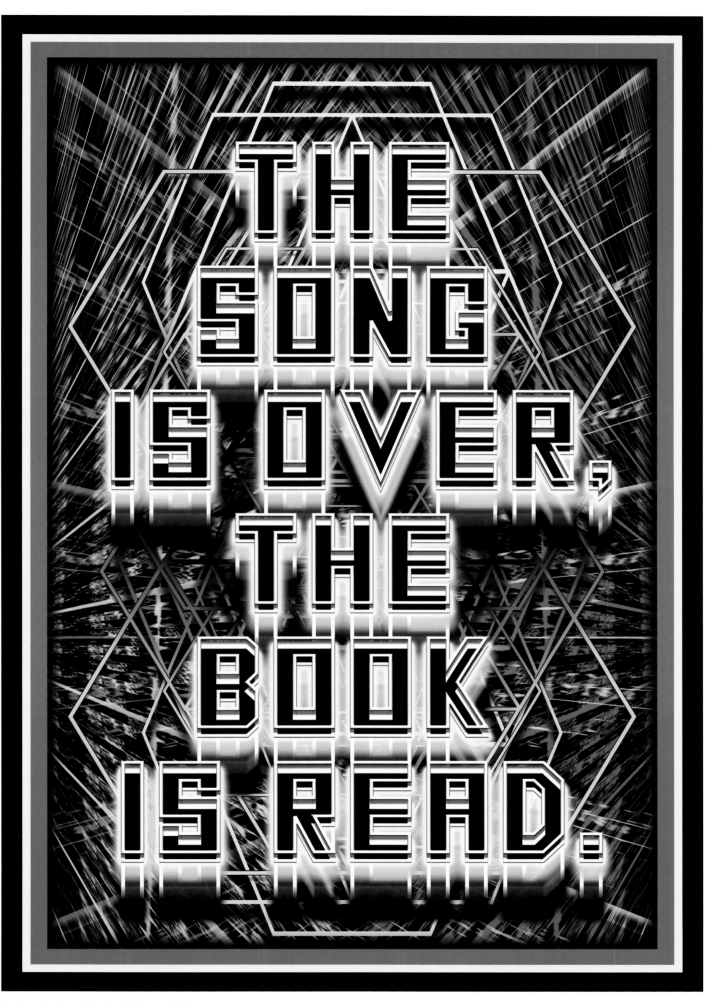

The Song Is Over, The Book Is Read., 2006
transparency in lightbox, 150 x 100 x 15 cm
Courtesy the artist and Vilma Gold, London

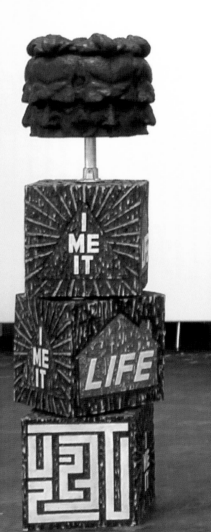

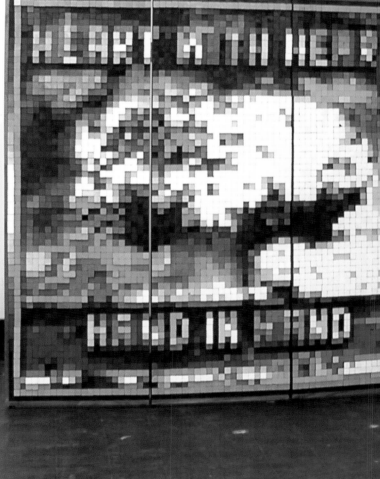

Installation view: *Behold The Man, Waiting For The Man*, 2005
Peres Projects, Los Angeles,
Courtesy the artist, Vilma Gold,
London and Peres Projects, Los Angeles Berlin

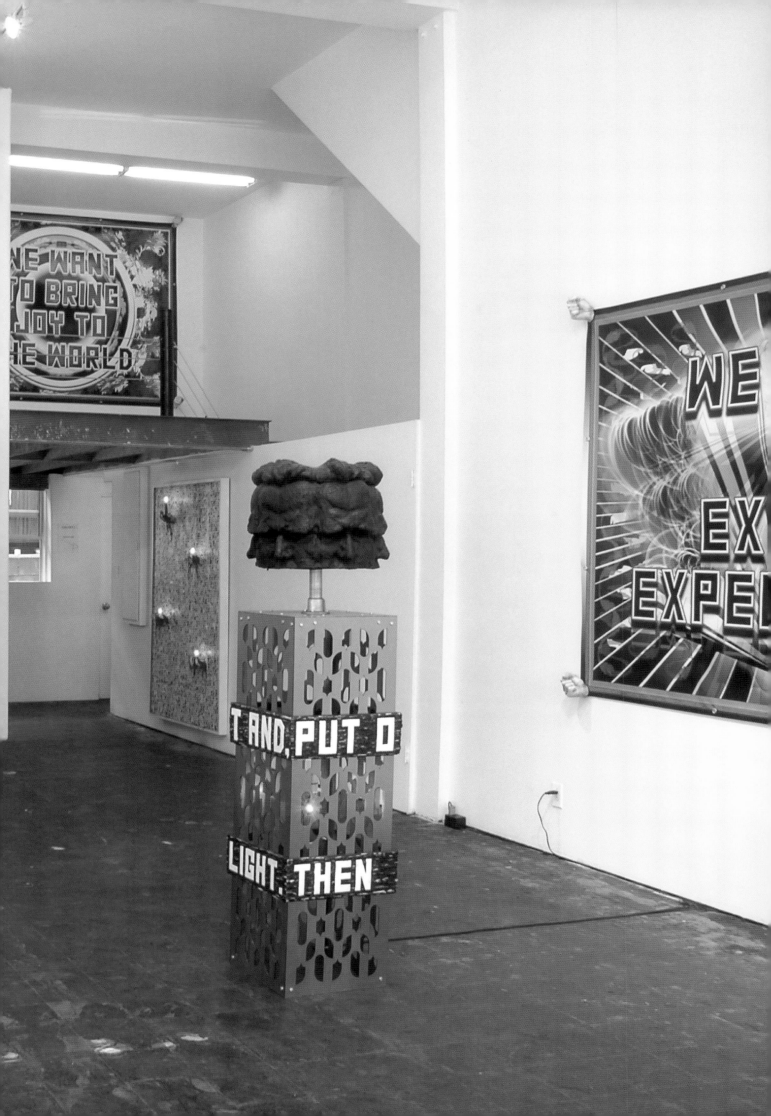

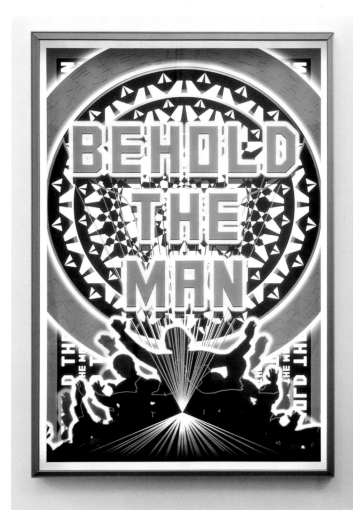 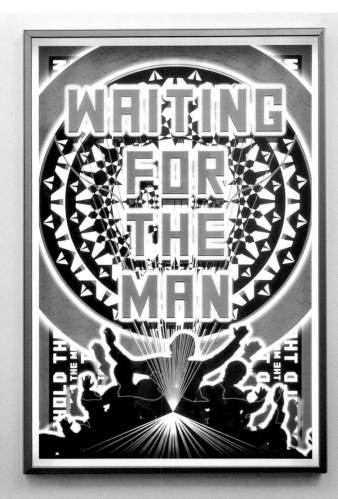

Behold The Man, Waiting For The Man, 2004
transparency in lightboxes
diptych: each part 185 x 125 x 15 cm
George Hartman and Arlene Goldman Collection, Toronto

Opposite: *Why Not Say Yes?,* 2004
ink, paint, wood, plaster, candles, 184 x 124.5 x 17 cm
Beth and Anthony Terrana, Boston

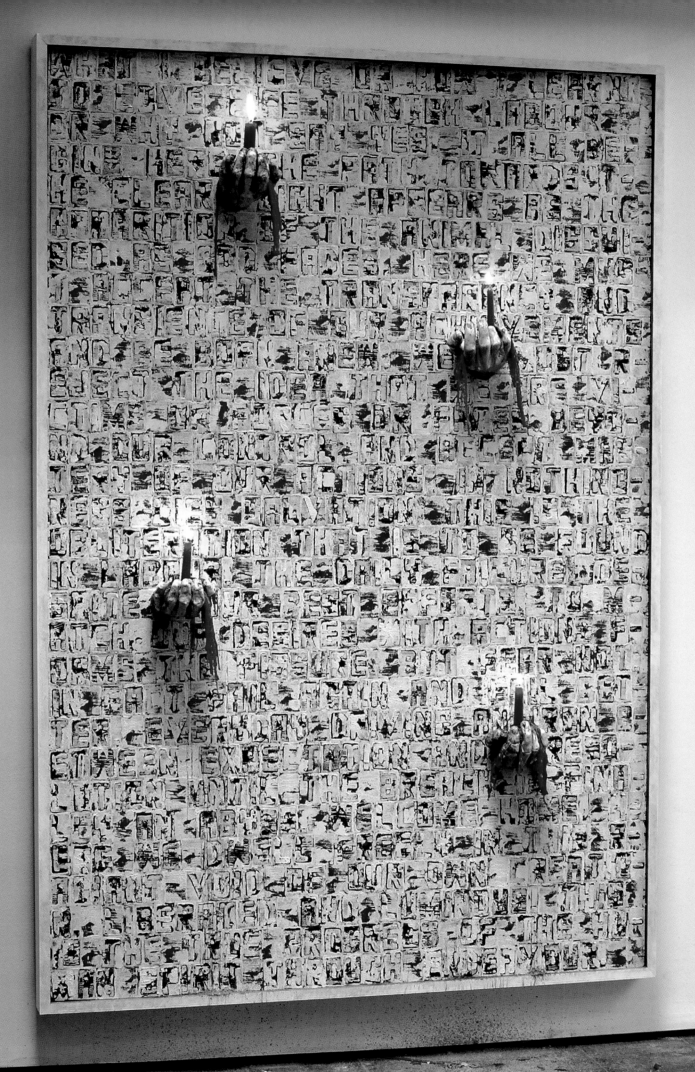

Stills from: *Bedtime For Necromancy*, 2004
DVD, duration 2:52
Courtesy the artist, Vilma Gold, London and Peres Projects,
Los Angeles Berlin

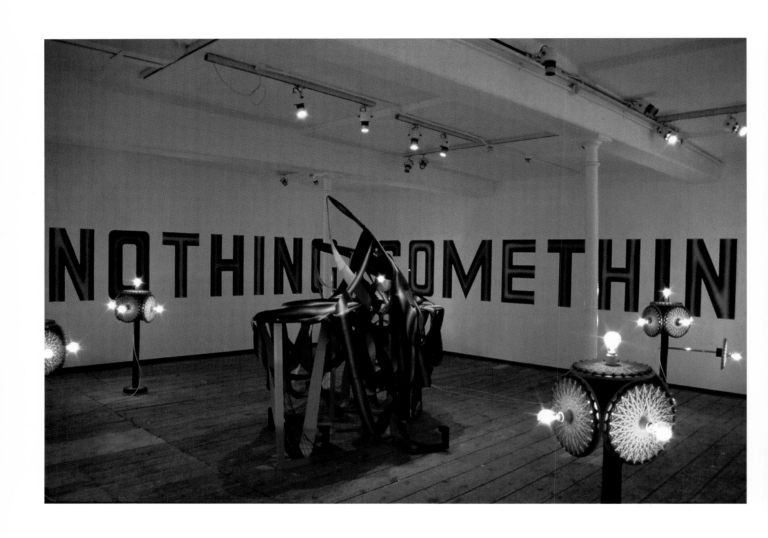

Installation view: *Something Plastic To Fight The Invisible,* 2001
Courtesy Arts Council Collection, Hayward Gallery, London
and the artist and Vilma Gold, London

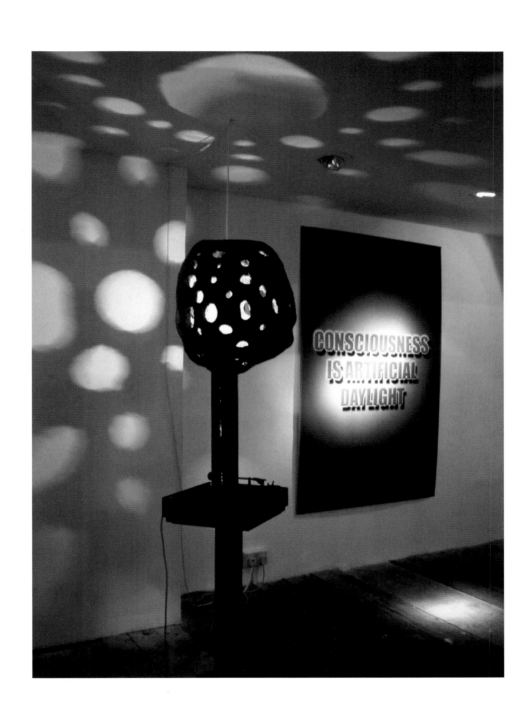

Installation view: *Something Plastic To Fight The Invisible,* 2001
Private Collection, London

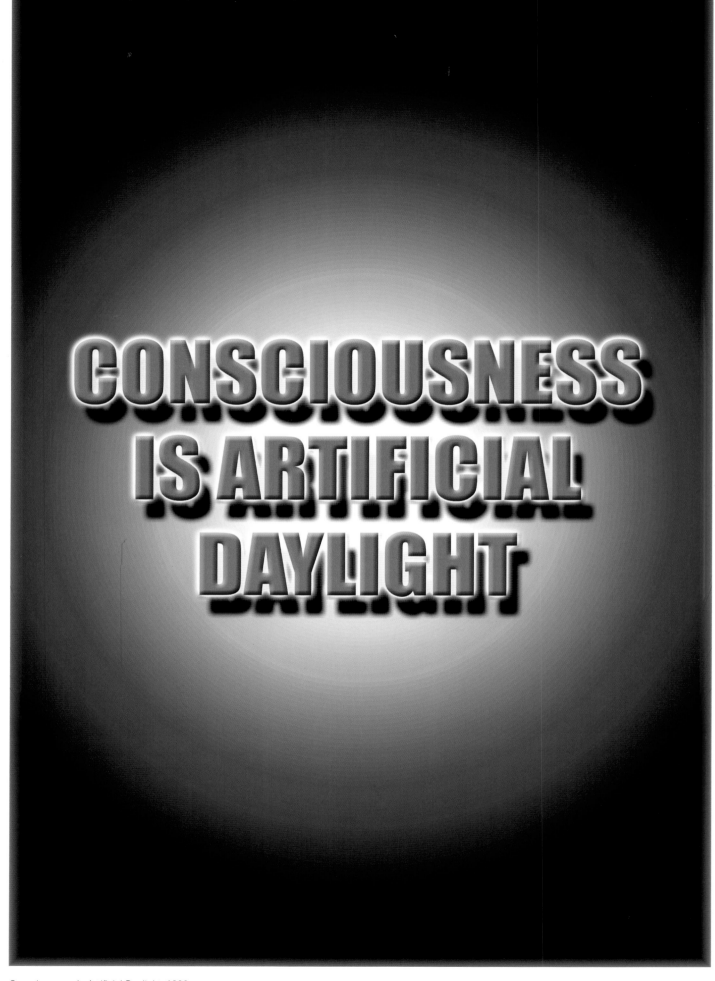

Consciousness Is Artificial Daylight, 1999
transparency in lightbox, 180 x 120 x 15 cm
Private Collection, London

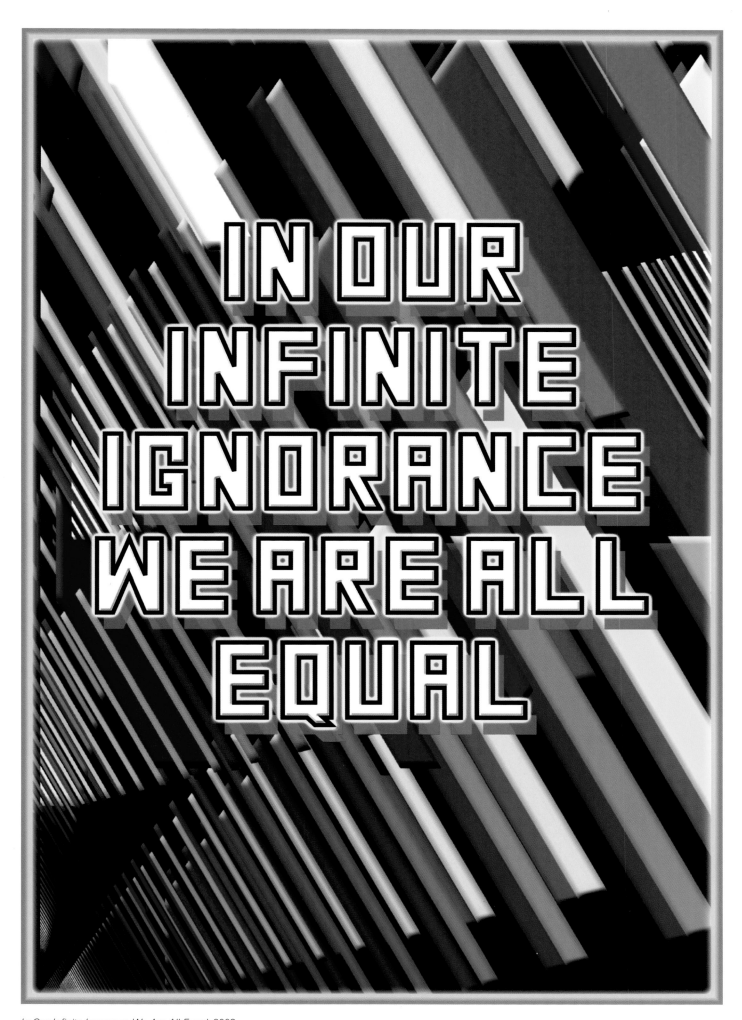

In Our Infinite Ignorance We Are All Equal, 2003
transparency in lightbox, 180 x 120 x 15 cm
Private collection

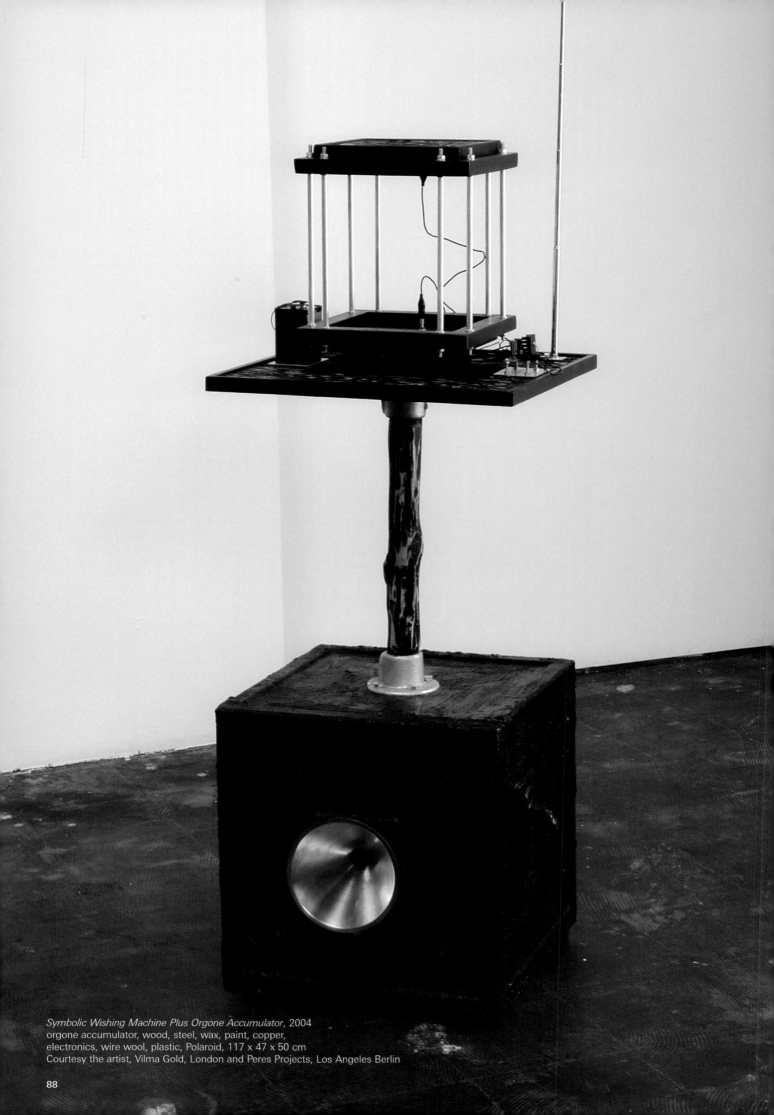

Symbolic Wishing Machine Plus Orgone Accumulator, 2004
orgone accumulator, wood, steel, wax, paint, copper,
electronics, wire wool, plastic, Polaroid, 117 x 47 x 50 cm
Courtesy the artist, Vilma Gold, London and Peres Projects, Los Angeles Berlin

MARK TITCHNER AND MARTIN CLARK IN CONVERSATION, DELFINA STUDIOS, FEBRUARY 2006

Recorded with Sanyo Talk-Book circa 1996 onto Olympus XB-60 microcassette.

SIDE 1

Click

Martin Clark: Lets start by talking about the new work you have made for the show here at Arnolfini, *How To Change Behaviour (Tiny Masters of the World Come Out)*, (2006). Like a number of your recent installations it's a very dense, complete environment and it's also interactive.

Mark Titchner: This work comes out of ideas I have been thinking about and working with for some time now; the idea that sculpture might have a use value, that it might exist as an aesthetic object, within an art context, as well as something that has a practical, experimental application. I'm interested in the idea that the audience might form a very particular control group. Like the earlier work I made at Tate Britain, *Be Angry But Don't Stop Breathing*, (2003), this piece requires its audience – the active participation of the viewer – to complete the work.

MC: In the case of *How To Change Behaviour…* audience members are asked to engage with Radionics equipment, an obscure metaphysical technology that is used in spiritual healing I believe.

MT: Yes, the Radionics boxes are basically wish amplifiers. The operator uses them to try and effect a change in the physical world by amplifying psychic activity. For this installation I have wired eight of these boxes in series. The aerial they are all connected to is based on the famous Wishing Tree in Hong Kong. Viewers are invited to use the equipment to wish the installation, the objects themselves, well.

MC: And how much do you really invest in the audience's participation? I know that the objects are based on, and produced as, fully functioning working models, but how much do they remain potential objects, objects which are operational but still essentially signify their use?

MT: Well, with *Be Angry…* there was a very concrete result, an immediate physical consequence: you screamed into a mouthpiece and it registered as movement on the surface of a pool of water. But

with *How To Change Behaviour…* the outcomes are perhaps more complicated, certainly more oblique. There is no apparent physical resolution or consequence, rather, it asks the viewer to actively engage with the work, but it is unclear as to exactly what is being asked of them. It is perhaps impossible to either prove or disprove any *effect* they might have. In this way it is something like prayer, meditation, spiritual healing or even homeopathy. However, there is of course that sense that the invitation might be a reflexive one and need not be actually acted upon physically (or in this case psychically) for the work to still operate on some imaginative level.

MC: From an art historical context you can think about the relationship of the objects to the viewer in terms of a tradition of minimalist and post-minimalist sculpture. That attempt to engage with, and activate, the physical body of the viewer – I'm thinking of someone like Robert Morris or Carl Andre – which in your work is taken to an almost eccentric extreme.

MT: It is really interesting to look at that relationship between the object and the body now, to think about how that has developed. Objects for us are utilitarian extensions, ways of augmenting, enhancing or improving the body. There is, increasingly, this reliance on machinery, technology. But I also like the idea – in particular when I am invited to show in institutions like Arnolfini or Tate, these rarefied 'art' spaces – that the viewer is invited to touch the works. This sculpture is meant to be handled, people are meant to step inside it, to engage with it on something other than the purely visible or cerebral level.

MC: I'm fascinated by the idea of technology as a prosthetic, something which can be seen as a kind of superhuman augmentation, a bionic analogue for our various biological and intellectual functions. What's interesting in *How To Change Behaviour…* though, is that you are asking the viewers to focus on the technology itself. The invitation or instruction is to try and enable the works, the objects, to improve themselves, to develop, become better.

MT: Yeah, well this has to do with ideas of evolution. The next evolutionary stage in terms of technology is thought to be when computers become sentient, when they achieve some kind of concious-

ness, can program themselves. Another take on it would be to do with the investment we have now in machines – the way that we care about machines, technologies and objects, perhaps more than other people on a global level. So the invitation in this work is for each individual to attempt to do something extraordinary, extra-sensory, super-human, but rather than trying to change the world, all of these efforts are focussed back onto the object itself, it's a kind of selfish loop, a feedback.

MC: And this selfishness you talk about isn't necessarily negative. It's the same action, the same self-interest, required by all species for their survival. Selfishness is the fundamental requirement for evolution. So this idea of technological evolution, selfish machines, simply mirrors the laws of nature. Interestingly, the machines are employing biological beings to engineer and assist. I guess the question is at what point they no longer require our intervention? At what point we become superfluous? And what happens then?

MT: If the human will really could alter matter, change objects, improve the world, then this work reflects the fact that, in our society, exactly these kinds of extraordinary human capabilities are almost always hijacked for reductive, selfish, individualistic ends. The paradox is that we are constantly undermined by our own selfish natures which are, of course, the very drives which propel us toward greatness. Our inevitable failure is basically inbuilt.

MC: These sculptural works and installations have always been an incredibly important part of your practice, but many people are, perhaps, more familiar with your digital and graphic works: the lightboxes, banners, wall drawings and posters. But these sculptural objects are almost their antithesis, both aesthetically and in the way that they are produced – laboriously hand carved, employing primitive craft techniques. I guess the commonality between both bodies of work is your incorporation of text, though on the object it appears incredibly physically.

MT: I'm interested in the idea that inscription, in any form, is a manifestation of that act of will – the act of writing following the act of speaking. And there is this gap, of course, between the potential of the text and someone actually acting upon it. But in terms of the aesthetic, I like the idea that these are almost fetish objects, the kind of thing a lunatic might make in his garden shed, like the carved books the Unabomber made to keep his bombs in. There is this idea that by obsessing over an object, by crafting it, labouring over it, it becomes invested

with some kind of power, even if that is only in the mind of the person making it. There's a rich history of anomistic, hand-crafted, religious fetish objects.

MC: I guess those ideas of power find their echo in the secular art world as well. In the traditional idea of the 'work of art' as a worked on object, something directly modelled and manipulated by the hand of the creator genius. Again there is this investment, this aura, around the hand of the artist, their physical manipulation of the object, their obsession, humanity, desire.

MT: I'm basically interested in what humans can do with the technology available to them at any particular moment, what they can do with the tools that are at hand. That's why I'm interested in the tradition of the craft movement. For me there is a direct analogy between the craft movement and the laptop computer or digital media. You can now – within your own home – produce print, music, video and graphics, very easily. The tools are readily available, democratised to some extent, it makes the scale of those things very domestic again.

MC: A 21st century cottage industry. Coming back to the texts, though, I have always been interested in the way that you construct words and phrases within your work. It makes me think about the etymology of the word 'spelling', spelling in both it's grammatic and mystic/occult senses. In both disciplines the term roughly translates as the deliberate arrangement of abstract, autonomous, signs or symbols in order to produce effect, or perhaps meaning. In both cases spelling is a powerful and potent activity. In the candle pieces you've made for instance, that idea feels very apparent. Each of the individual letters is arranged as a series of discreet blocks, carefully ordered to create a text. And the text itself is slightly arcane sounding, certainly very strange, cryptic even.

MT: Well if you think about all magical systems, the end point is usually to enable you to impose your will on some outside object or other. Those candle pieces are about a moment of lucidity, clarity. It is almost an epiphany, which is why they have that strange poetic tone to them. They are still made of various found texts, but they read in the first person. They are like chapels to a moment of revelation, of clarity.

MC: Formally they are very self-contained and I love the way that they feel like devotional objects. They are also self-illuminating – illuminated texts! – with those almost absurdly gothic hands and candles. There's a nice relationship to the lightboxes, too,

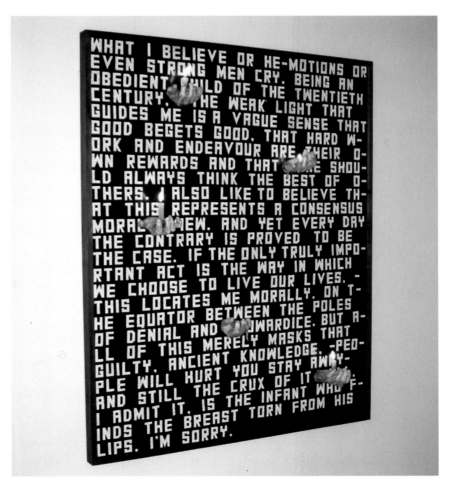

*How To Change Behaviour (Tiny Masters Of The World
Come Out),* (detail), 2006
carved wood, paint, metal, plastic, electronic components,
quartz crystals, laboratory glass, wood and metal dust
dimensions variable
Courtesy the artist and Vilma Gold, London
Commissioned by Arnolfini

He-Motions, 2004
resin, paint, wood, plaster, candles, 180 x 120 x 25 cm
Private Collection, USA

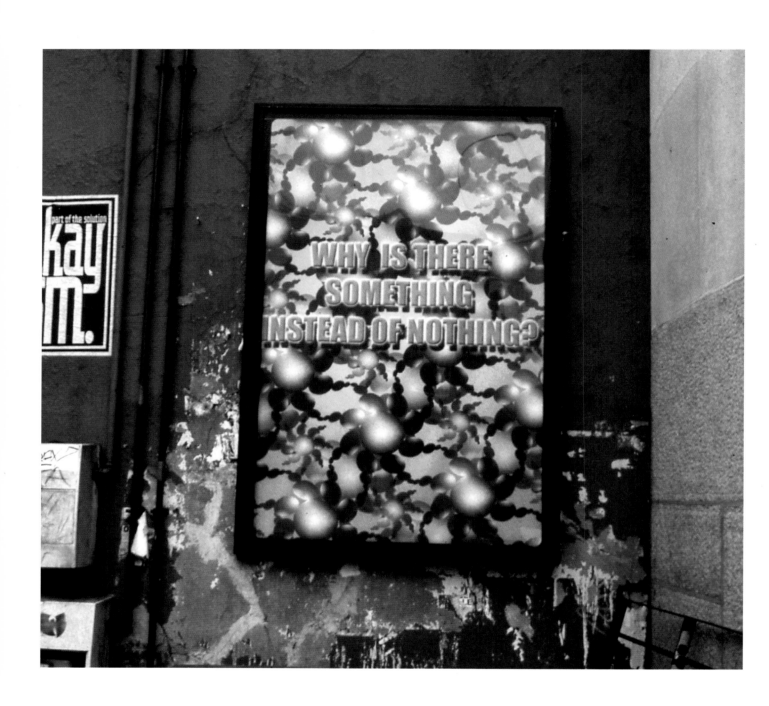

Why Is There Something Instead Of Nothing?, 2000
transparency in lightbox, Hoxton Street, London
180 x 120 x 15 cm
Courtesy the artist and Vilma Gold, London
Commissioned by Mustafa Hulusi

which are also self-illuminating, but employ the more technological apparatus of fluorescent electric strip-lights.

MT: Yes, they are kind of monuments to illumination, to revelation. Those works came out of woodblock prints I was making. I wanted to slow the process of writing right down, to try and produce these 'slow-rants'. Printing sentences letter by letter does this. I would start with the words: "I believe…" and then, by the time I had reached the end of the phrase, some 10 or so minutes later, I would have created enough time and space for all sorts of doubt to creep in: you know, maybe I don't believe that at all now! The candle pieces are similarly slow to produce, casting each letter and then arranging them in sequence. The hands are there to try and stop the things becoming too austere. I use hands quite a lot in my work, for me they are representative of another form of communication, pre-linguistic, primitive, expressive, gestural.

MC: And also, I guess, they reference these other very complex, idiosynchratic, or even secret languages – from sign language through to the casting of spells, masonic handshakes, the hand-symbols of street gangs. You use images of hands in a number of your lightboxes. For this show we've brought together lightboxes made over the last 8 or so years. They seem to have become something that you produce quite regularly, a kind of constant in your practice, maybe it would be interesting to talk about how they have changed, both aesthetically and in terms of their position within your practice, since you began making them?

MT: I think the first thing to say is that the reason I began making those lightboxes was because I had a show on at a gallery in London, Vilma Gold, and a friend of mine, Mustafa Hulusi, ran a project in a lightbox on a street nearby. He invited me to make a poster for it. I had never worked with any digital media before, but as soon as I began working on it I knew that this was it for me. I had given up painting a few years before as a student, because I wasn't able to achieve the results that I wanted. But working with digital packages I was suddenly able to do exactly what I had wanted to do with painting and drawing, it was a real awakening. But as I say, that poster was made for a lightbox on the street, it had a social context, it was out there in the world. The first one used the text: 'Why Is There Something Instead Of Nothing?' and I guess that's been the fundamental question for all of the lightboxes since.

MC: It's a good starting point.

MT: I'll probably finish with that one as well! Back then the poster works that followed were always made for a social context, they were often fly-posted or given away, but they have slowly turned into much more gallery-based objects. What I like about the lightbox as an object is that it's big, it's shiny, it lights up, it basically screams 'look at me'. It is designed for advertising, it wants you to like it in a very immediate, shallow way. There's a simple, but I think satisfying, contrast between these big statements about the nature of existence, the universe, and their mode of display. There is a kind of blankness to the works which I find is even more marked, even more keenly felt, when they are put into the context of the gallery.

MC: Aesthetically, they have changed quite a lot, albeit within a reasonably rigid set of parameters. The font you used in the early works has been replaced with a font you have designed yourself and which you now use in all of your works. But the imagery has developed too – the earliest ones looked pretty basic in a way. They remind me of flyers for some early 90's rave, produced in a kids bedroom on a generic software package – they reference the idea of the future, the cutting edge, but attempt to realise it through an off-the-shelf, home computer, graphics programme.

MT: To be honest, they look like that because that was basically the best I could do with *that* software and *my* skills back then. It really was about pushing the technology, however domestic, to it's, or maybe my, limit, and then going with that, however far short it fell of any idea of professionalism.

MC: And then you started bringing in more sophisticated design and patterning, quoting much more consciously – the William Morris patterns, the trade union banners…

MT: Yeah, well I mean those particular pieces followed on from the work I made for Gloucester Road Tube station *I WE IT,* (2004), where I quoted texts from the corporate manifestos of the top 10 global brands. I wanted to contrast this new form of economics with utopian socialist ideas from the early 20th century, hence the use of the trade union designs. But for the most part I try not to set up too direct or strong a relationship between the text and the imagery. The text is always found, it can come from anywhere: song lyrics, philosophy, literature, scientific research, and through this process it all becomes equivalent. I want the backgrounds to remain as neutral as possible in order to allow for this equivalence, to avoid referencing the source of the material. I don't want them to reveal their context.

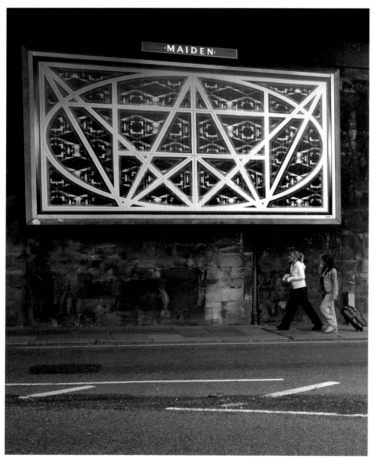

Top: *English Language Golem*, 2001-2006
database program, computer, speakers
dimensions variable
Courtesy the artist and Vilma Gold, London

Bottom: *Belief Is The Fall From The Absolute,* 2005
billboard, Newcastle
Courtesy the artist and Vilma Gold, London
Commissioned for *British Art Show 6* by the Hayward Gallery, London

MC: So it's about trying to find something purely decorative, seductive but empty?

MT: Again, it comes back to this idea of an epiphany, a moment of rapture. I think this is why they have become more and more over-wrought. It's about keeping on pushing, trying to find some kind of graphic representation for lucidity. What has happened is that they have become more and more overloaded. The kind of material I look at when I'm thinking about those works – religious posters, psychedelic artwork, evangelical leaflets, club flyers – are all trying to depict this other, transcendent state, graphically. And more often than not this is done through excess.

click

SIDE 2

click

MC: We've got 30 minutes left on this side of the tape so maybe we should talk about some particular works in more detail. We've mentioned *I WE IT* that you made with Platform for Art at Gloucester Road Tube station. Maybe you can talk a bit more about this piece, as I know it was the predecessor for another of the new commissions you have produced for the show here at Arnolfini: *The Invisible Republic* (2006).

MT: Well, again, I began thinking about that work in terms of its context. Those kinds of sites on Tube platforms are usually used for advertising, and in fact the position where the work was sighted faced the usual advertising billboards. I got the scoreboard for the top ten global brands and went through their corporate manifestos. I was interested in the fact that I had these ten sites and I was thinking about The Ten Commandments, the 'Thou shalts…'. I wanted to invert that somehow and remembered another ten point manifesto, the *Ten Point Program* of the Black Panthers which prefixed every demand with the words 'We want…'. I thought this was an incredibly simple but incredibly powerful inversion. It was aggressive, demanding, and absolutely evocative of this idea which we talked about earlier of 'collective will'. So I took the 'We want' and conflated it with the ten statements from these corporate manifestos. It was interesting because the advertising opposite all basically said 'you need…' or 'you want…', and at least a couple of the adverts were from the same companies that I was quoting.

MC: The tone of those works is extraordinary, they read like these evangelical or new-age aspirations or ideals. It is really bizarre to discover that they come from the world of corporations, of big business, what you think of as an ultra-conservative space.

MT: What fascinated me was exactly this language of improvement, of utopian idealism that the companies were employing, at the bottom line in order to increase productivity and profits. With capitalism that is always the bottom line. I contrasted it with the aesthetic of the trade unions banners which was also about labour, work and workers. But it was an attempt to point out this shift from labour, from productivity, to consumption. Our main role now, our job, is to consume as much as possible as fast as possible.

MC: For the new work *The Invisible Republic,* you revisited that corporate brand scoreboard again, but the work feels very different. Both the format of the piece, and the addition of one simple element, utterly changes the tone and operation of the work. The statements now all appear on one long banner as an extended list, and each is preceded by the word 'and'. It has gone from being a balanced, idealistic set of autonomous aspirations, to a kind of greedy, cumulative, spoilt-sounding rant.

MT: The voice in *I WE IT,* is very powerful, authoratative. In *The Invisible Republic* it's more like a kind of unreasonable, paranoid, consumer. It is almost absurd, but more unsettlingly it points to a kind of endlessness and insatiability to our desires, our needs.

MC: I want to talk about another work in the show, *English Language Golem.* It's unusual in that it is a sound work, derived from a performance I believe, but then it's not unusual in that it is also a work about, and made up of, text, of language.

MT: The background to that piece was a work that I had been making in relation to Brion Gysin's *Dream Machine* – there is a whole aspect around that thing which is to do with permutation, and I read this essay about the Kabbalah and in particular the idea that language forms the structure, the building blocks, of the universe. I work with text a lot and I wanted to make a piece that treated it in a very different way from how I usually would, in this case incredibly schematically. The idea is that this computer program will systematically run through every permutation of letters in the English alphabet. On one hand it is a very structural activity, but I was also interested in the Kabbalistic idea that encrypted in language is a fundamental and all-powerful word; the name of God, the truth of the universe. In the legend of the Prague Golem, which lends the work its title, this word is discovered and used to bring to life, to animate, a clay sculpture of a man.

MC: So this work, which would take thousands of years to complete, will potentially discover that word, enunciate it, and maybe then the world will end, or maybe something will be summoned, conjured up?

MT: But the technology that is supporting the piece will inevitably breakdown before the work can be completed, so again, it's own failure, it's mortality, is built into it.

MC: In the show here you have paired the piece with a drawing by Austin Osman Spare, the artist and occultist who developed the system of Sigil writing, a language of occult magic which you have begun to use within your most recent works. It's interesting that that Sigil system is another mechanism for sequencing language, concentrating it, and attempting to produce effect in the world.

MT: His drawings are interesting too. They were often produced whilst he was in trance states, so they are, essentially, the residue of this other activity, this other experience. It's weird, I have been carrying around a cutting I have about Spare since I was about 15 years old. 18 months ago I was working on the billboards for *British Art Show 6* in Gateshead and I thought again about Spare and decided to use the Sigil system for that work.

MC: One of the things I like about *English Language Golem* is that it contains every other work in the show, every other text you use will potentially be spelled out by this work, generated by it. It produces this vast, inclusive universe, whilst at the same time reducing it to its most basic element, the singular letter. It's a kind of alchemical process. The fundamental elements of this universe are constant – the letters, the alphabet – yet their combinations allow for infinite variety. In your work, language, text, always feels like it is on the edge of breaking down into its constituent elements.

MT: Even in the digital works I am constantly working with fragments, breaking things down, building things up. It's a methodology I find very productive, it opens up interesting new lines of enquiry. It's this idea that if I can collect together enough of this stuff, these bits, then eventually they will produce meaning, purpose, but it's never ending, it's an eternal task.

Click

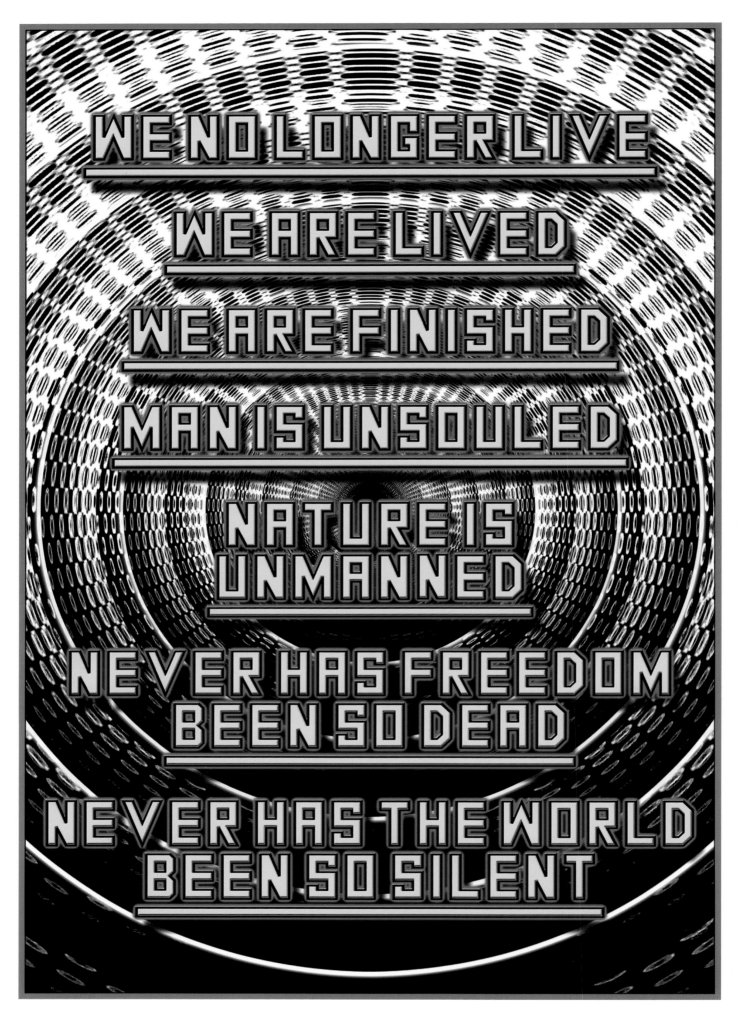

We No Longer Live, 2002
transparency in lightbox 185 x 125 x 15 cm
Collection Hunting/Van Esch, Eindhoven, The Netherlands

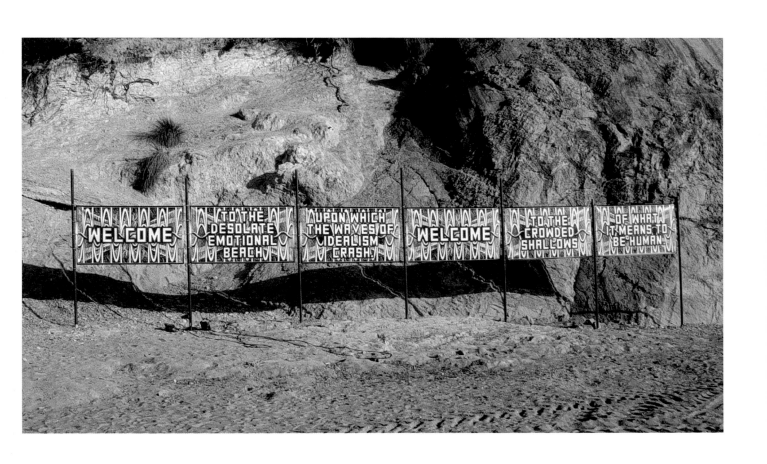

Welcome, 2004
digital print on vinyl, dimensions variable
Courtesy the artist, Vilma Gold, London and Vacio 9, Madrid
Commissioned for *Nit Niu*, Mallorca, 2004

MARK TITCHNER, BIOGRAPHY

1973 Born in Luton

1991-92 Hertfordshire College of Art & Design

1992-95 Central St Martins College of Art & Design

Solo Exhibitions (selected)

2006 *IT IS YOU*, Arnolfini, Bristol

2005 *When We Build Let Us Think That We Build Forever*, Vilma Gold project space, Berlin
Behold the Man, Waiting For the Man, Peres Projects, Los Angeles
After the Punchline… Eternity, Vacio 9, Madrid

2004 *20th Century Man*, Vilma Gold, London
MUSIK TOTAL III (Mark Titchner, Carlos Amorales & The Sun City Girls), De Appel, Amsterdam
I WE IT, Platform for Art, Gloucester Road Underground Station, London

2003 *Be Angry But Don't Stop Breathing*, Art Now, Tate Britain, London
Do Not Attempt To Reform Man. We Are What We Are, Galerie Jörg Hasenbach, Antwerp
We Were Thinking Of Evolving, Vilma Gold, London

2001 *Love, Work & Knowledge*, Vilma Gold, London

1999 *Mark Titchner*, Vilma Gold, London

1998 *Mark Titchner*, One in the Other, London

Group Exhibitions (selected)

2006 *Black and White*, American Hellenic Institute, Athens
Para todos los públicos, Sala Rekalde, Bilbao (cat.)

2005 *British Art Show 6*, touring exhibition beginning Baltic, Newcastle (cat.)
Hidden Rhythms, Museum Het Valkhof, Nijmegen (cat.)
Odiseado Tra Tempo, Peter Kilchmann Gallery, Zurich
Offside, Hugh Lane, The Dublin City Art Gallery (cat.)
Jaybird, Zero, Milan

2004 *showCASe*, South London Gallery, London
Vilma Gold at Galerie Diana Stigter, Galerie Diana Stigter, Amsterdam
If you think you see with just your eyes you are mad, Peres Projects, Los Angeles
Expander, Royal Academy of Arts, London (cat.)
Rear View Mirror, Kettle's Yard, Cambridge (cat.)
Britannia Works, Various venues, Athens (cat.)
Nocturnal Emissions, The Groninger Museum, Groninger

Asphalt and Neon, Museo Tamayo, Mexico City and MARCO, Monterrey (cat.)
Happy Go Lucky, (public art commission), VHDG, Leeuwarden (cat.)
A Secret History of Clay, Tate Liverpool, Liverpool (cat.)
Now is Good, Northern Gallery for Contemporary Art, Sunderland (cat.)
Candyland Zoo, Kent Institute of Art & Design, Canterbury

2003 *Electric Earth*, State Russian Museum, St Petersburg (cat.)
Strange Messengers, Breeder Projects, Athens
Talking Pieces, Museum Morsbroich, Leverkeusen (cat.)

2002 *The Movement Began With A Scandal*, Lenbachhaus Museum, Munich
The Galleries Show, Royal Academy of Arts, London (cat.)
The Dirt of Love, (with Roger Hiorns & Gary Webb), The Mission, London
Strike, Wolverhampton City Art Gallery (cat.)
Exchange, Richard Salmon, London

2001 *Sages, Mystics & Madmen*, One in the Other, London
Brown, The Approach, London
Playing Amongst the Ruins, Royal College of Art, London (cat.)
City Racing (A Partial History), ICA, London (cat.)
Best Eagle, (with Michele Naismith & Duncan McQuarrie), Transmission, Glasgow

2000 *Mark Titchner & Lena Seraphin*, Sali Gia, London
Point of View, (collection of Thomas Frangenburg), Richard Salmon, London
Mark Titchner & David Musgrave, Grey Matter, Sydney

1999 *Limit Less*, Galerie Krinzinger, Vienna
297 x 210, Arthur R Rose, London (cat.)
…..Nice to Meet You, Kunstbunker, Nuremburg
The Poster Show, Gavin Brown's Enterprise, New York
Heart & Soul, 60 Long Lane, London
Painting Lab, Entwistle Gallery, London

1998 *True Science*, KX, Hamburg
Surfacing, Institute of Contemporary Art, London
Sociable Realism, Stephen Friedman Gallery, London

1997 *Show 47*, City Racing, London

1996 *LIFE/LIVE, ARC*, Museum of Modern Art, Paris (cat.)

ACKNOWLEDGEMENTS

Arnolfini and Mark Titchner would like to thank the following individuals and organisations for their support and assistance in the development of the exhibition:

Jack Bakker, Mark Beasley, Justiene Boughey, The Delfina Studio Trust, The Elephant Trust, Mark Dickenson, Matt Doo, Paul van Esch, Clare Ewer, Jörg Hasenbach, Martin Herbert, Colin Ledwith, Christian Linde, Petra Lintern, Andrew Mania, Marta Moriarty, Shane Munro, Gregory Papadimitriou, Peres Projects Los Angeles Berlin, Javier Peres, Steve Pippet, Emily Power, Alun Rowlands, Kirsten Strunz, Rachel Williams and Chelsea Zaharczuk.

All images courtesy the artist and Vilma Gold except where stated.

Arnolfini installation shots pages 7-17 copyright Jamie Woodley Photography.

Page 55 Ed Ruscha, "Museum on Fire #1", 1968 Collection Museum of Modern Art, New York Image courtesy the artist and Gagosian Gallery, Los Angeles.

Ed Ruscha, "Study for the Los Angeles County Museum on Fire (museum study #2)", 1968, Collection Hirschhorn Museum and Sculpture Garden, Smithsonian Institute, Washington DC. Image courtesy the artist and Gagosian Gallery, Los Angeles.

Page 58 Images of Spanish Civil War torture cells reproduced in "Anarchists in the Spanish Revolution", by Jose Peirats. Published by Freedom Press, London, 1998. ISBN 0 900384 53 0.

Page 59 Still from "Un Chien Andalou", 1929. Director: Luis Buñuel, Image courtesy The Kobal Collection.

Page 61 Still from "A Clockwork Orange", 1971. Director: Stanley Kubrick, Image courtesy The Kobal Collection.

Page 94 Belief Is The Fall From The Absolute, 2005 billboard, Newcastle
British Art Show 6 at Baltic
Photo: Colin Davison

Published by Arnolfini on the occasion of the exhibition Mark Titchner, IT IS YOU 25 February – 23 April 2006

ISBN 0 907738 80 X

Edited by Martin Clark
Catalogue design Petra Lintern
www.divalldesign.com

Distributed by Cornerhouse Publications

Printed by The Marstan Press

Arnolfini
16 Narrow Quay
Bristol BS1 4QA
T +44 (0)117 917 2300
F +44 (0)117 917 2303
info@arnolfini.org.uk
www.arnolfini.org.uk

ARNOLFINI **VILMA GOLD** The Elephant Trust out of the George Melhuish Bequest.

Supported by **The National Lottery®** through Arts Council England & The Millennium Commission